IMAGES
of America

DUPONT CIRCLE

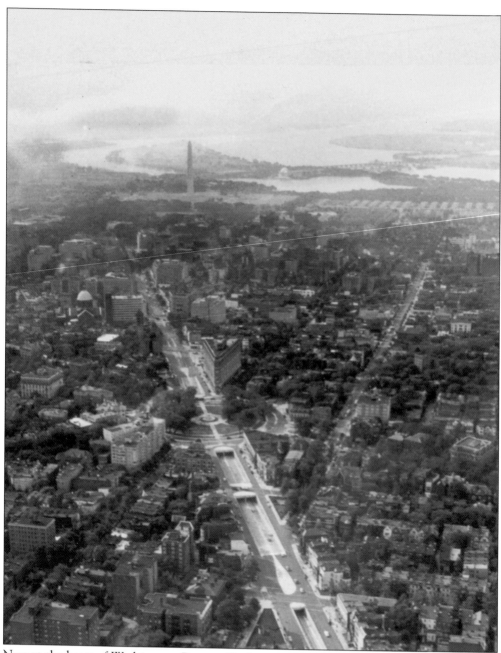

Now at the heart of Washington, Dupont Circle, just 100 years ago, was being developed as a suburban community of lavish homes and exquisite shops a few miles from the White House. (Courtesy of the Washingtoniana Division, MLK Library.)

IMAGES
of *America*

DUPONT CIRCLE

Paul K. Williams

ARCADIA
PUBLISHING

Published by Arcadia Publishing
Charleston, South Carolina

Printed in the United States of America

Library of Congress Catalog Card Number: 00-106601

For all general information contact Arcadia Publishing at:
Telephone 843-853-2070
Fax 843-853-0044
E-mail sales@arcadiapublishing.com
For customer service and orders:
Toll-Free 1-888-313-2665

Visit us on the Internet at www.arcadiapublishing.com

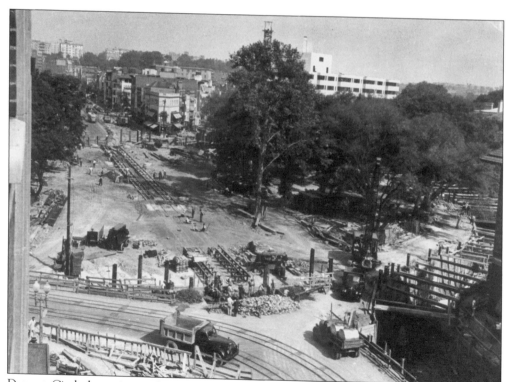

Dupont Circle has witnessed several significant changes since its origins as Pacific Circle in the 1870s, including a new fountain, landscaping, traffic and trolley tunnels, and its transformation from a residential circle to a commercial core. (Courtesy of the Washingtoniana Division, MLK Library.)

CONTENTS

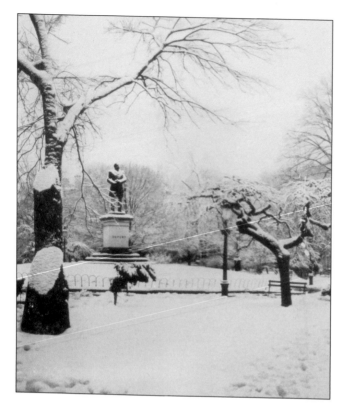

Dupont Circle has long been a gathering spot in every season from the Victorian period to the gay rights era. (Courtesy of the Washingtoniana Division, MLK Library.)

ACKNOWLEDGMENTS

The author would like to thank all individuals, friends, and family members who provided assistance during the production of this book. Far from a complete history of such a complex neighborhood, its purpose is to build on past resources and offer material that will enlighten, enhance, and perhaps surprise both residents and visitors alike.

Special thanks goes to the staff at the Library of Congress Prints and Photographs Division, Gail R. Redmann of the Washington Historical Society, and Mary C. Ternes, Matthew Gilmore, and Faye P. Haskins of the Washingtoniana Division of the Martin Luther King Memorial Library for their many, many trips back and forth to their outstanding photographic resources.

INTRODUCTION

The history of Dupont Circle is both varied and complex, although not as old as one might expect. The area was designated as a place for special merit on Pierre L'Enfant's 1791 plan of Washington as the intersection of Massachusetts, Connecticut, and New Hampshire Avenues with Nineteenth and P Streets, but the land was not part of the original purchase of land by George Washington for the Federal City. It would remain marshy, wooded, and devoid of development, with the exception of large country estates, until the 1870s.

The city of Washington remained small until the tremendous influx of residents following the Civil War. The large mansions of the wealthy existed in other areas of the city, including Capitol Hill, Logan Circle, and the newly acquired port of Georgetown. Originally coined Pacific Circle, the area was designated Dupont Circle in honor of Francis DuPont in 1884 when a statue of the Civil War Naval hero was erected at its center and the park was landscaped.

The vast open spaces of Dupont Circle, combined with savvy real estate speculators and massive city-wide improvements in the mid-1870s, prompted the relocation of wealthy residents to the neighborhood. There they could build larger mansions along grand avenues in a scale never before seen in Washington. At its peak in the 1880s and 1890s, Dupont Circle became home to future and former presidents, statesmen, foreign dignitaries, daring socialites, and some of the country's most wealthy industrialists. This unusual mixture of personalities, power, and wealth made Dupont Circle one of the more unique neighborhoods in the country.

Upper-middle-class Victorians secured their townhomes along the neighboring, tree-lined streets, purchasing their completed homes from developers who often built entire blocks at one time in a speculative nature around the turn of the twentieth century. The area continued to thrive and attract shops of international renown along Connecticut Avenue in the 1910s and 1920s. In 1923, the DuPont statue was replaced by a large marble fountain designed by noted sculpture Daniel Chester French.

In the summers of the 1920s, residents gathered in the Circle to hear military bands and to stroll among the great variety of flowering trees and shrubs. However, to accommodate increasing traffic, Connecticut Avenue was widened later in that decade, as the many automobiles, horse buggies, and trolley cars competed for the same space. The Riggs Bank building that went up on the site of one of the Circle's first mansions in 1923 signaled the change in use of many of the properties from residential to commercial.

During World War II, many of the large mansions and townhouses became rooming houses for the huge influx of government workers aiding the war effort. When many of them stayed in Washington following the war, a number of homes were replaced by apartment buildings and hotels in the 1950s. More than 52,000 vehicles a day in 1947 were rounding the Circle, which prompted construction of an streetcar underpass beneath the Circle just two years later.

The aging Victorian architecture of the neighborhood fell upon hard times in the 1960s, and the Circle became a gathering place for homeless, hippies, and drunks. It also was a gathering place for early homosexual rights protests and Vietnam War demonstrations during this era. However, the area began a revival in the 1980s as many of the very same protesters began renovating homes in reaction to the widespread demolition of old homes and buildings. The area was first demarcated as a historic district in 1977, beginning a trend of proud ownership and civic involvement that continues to this day.

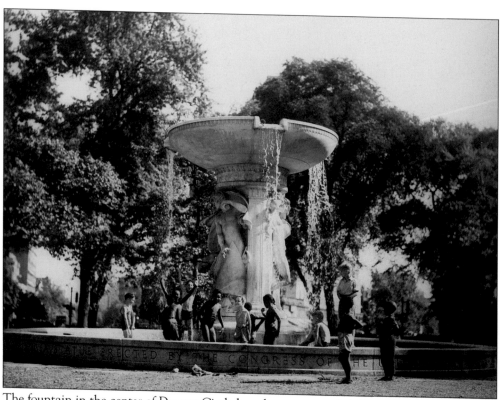

The fountain in the center of Dupont Circle has always attracted children on hot summer days such as these youngsters captured in the 1940s. (Courtesy Library of Congress.)

One

THE DEVELOPMENT AND EVOLUTION OF
DUPONT CIRCLE

Architect of the Capitol Pierre Charles L'Enfant planned Massachusetts Avenue as a transverse street crossing the city diagonally from the Eastern Branch to Rock Creek with a multitude of intersecting circles, including one then-named Pacific Circle, later renamed Dupont Circle. For the first 100 years following the throughfare's design, the northernmost termination of Massachusetts Avenue was just west of Dupont Circle and long stretches of marshy terrain along its route and around the circle itself sustained any residential development.

A few large estates occupied portions of what was to become Dupont Circle, which in the 1870s included low-lying areas of woods and fields frequented by sportsmen. In 1871, a group of real estate speculators, later known as the "California Syndicate," began buying up property in the area. As part of the large-scale, city-wide improvements executed by the Alexander "Boss" Shepherd of the board of public works between 1871 and 1873, many streets were paved, and in 1873, the first of many palatial residences was built on Massachusetts Avenue at Dupont Circle by silver magnate Senator William Stewart.

The circle itself was renamed Dupont Circle in honor of Samuel DuPont in 1882, and a statue of him was placed at its center two years later. It was replaced by the current memorial fountain in 1923. Trolley and vehicular underpasses were constructed in the late 1940s, and the Circle re-landscaped several times before construction began on the Metro system in the early 1970s in the bedrock far below.

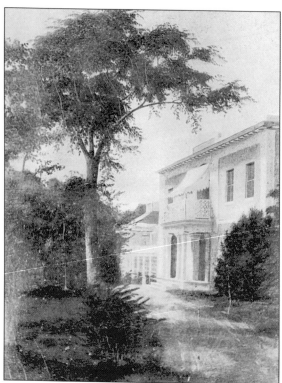

Before the development of the present Dupont Circle residential area, the land was occupied by large country estates such as this one called Kalorama, built in 1807. It featured over 100 acres of agricultural and landscaped lawns and an extensive mansion. It was owned by Joel Barlow, who had significantly enlarged a former house, called Belair, to the designs of noted architect Benjamin Henry Latrobe. (Courtesy of the Historical Society of Washington.)

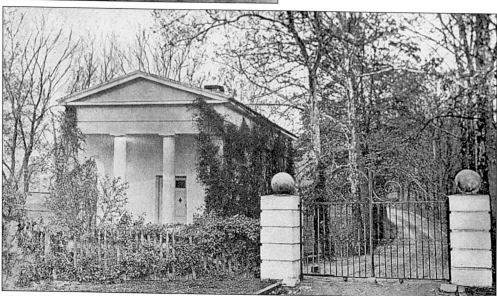

The Kalorama estate remained along the emerging Connecticut Avenue corridor until about 1900 and had access from the avenue via an elegant front gate with gatekeeper's cottage. The estate became a gathering place for many illustrious figures including Thomas Jefferson and Robert Fulton but was later occupied by an Illinois regiment during the Civil War and used as a smallpox hospital. In 1865, large parts of the estate were sold to raise funds for the mansion's restoration, thus opening new tracts of land for residential development. (Courtesy of the Historical Society of Washington.)

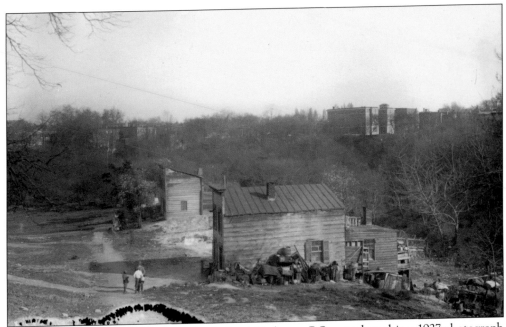

These frame houses were located in Rock Creek Park near P Street when this c. 1927 photograph was taken. The view shows the rural nature of the area, having only been developed in the prior 50 years despite its location only 8 blocks from the White House. (Courtesy of the Historical Society of Washington.)

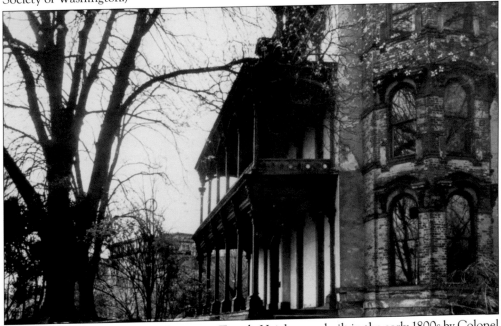

Situated on 10 acres, the estate known as Temple Heights was built in the early 1800s by Colonel Michael Nourse on land that is today occupied by the Hilton Hotel. A member of a prominent family, Nourse's brother Joseph served as the registrar of the treasury from 1789 to 1829. The estate was later owned by Thomas Morgan, a D.C. commissioner, before being purchased by the Masons in 1922. (Courtesy of the Washingtoniana Division, MLK Library.)

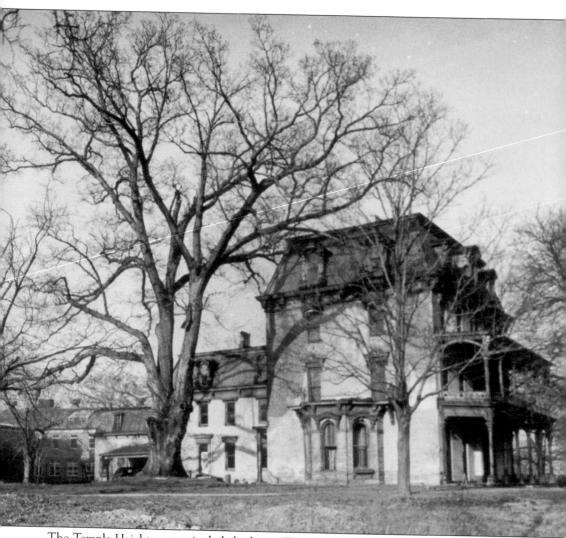

The Temple Heights estate included a large "Treaty Oak" on the western side of the mansion. The tree was significant as a meeting place where many Native Americans had dealings with early white settlers in the area. The *Evening Star* newspaper ran this photograph on April 4, 1948 and revealed that the house and tree were to be "dismantled this week" for a shopping center. (Courtesy of the Washingtoniana Division, MLK Library.)

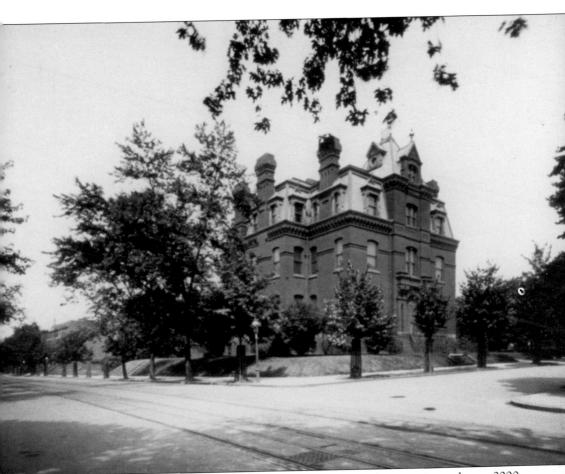

One of the first houses to be built around the Circle and one that remains today at 2000 Massachusetts Avenue was the Blaine mansion, built in 1881 for Maine senator James G. Blaine. Designed by architect John Fraser, the home was later purchased in 1901 by George Westinghouse, the founder of the company that bears his name. He remained there until his death in 1914. (Courtesy of the Washingtoniana Division, MLK Library.)

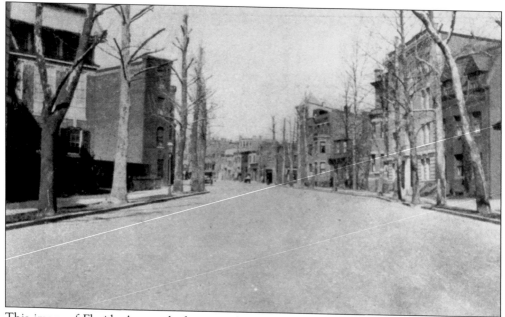

This image of Florida Avenue looking north from Massachusetts Avenue shows the street as a wide boulevard with mature trees. Florida Avenue was the original boundary of the city of Washington and as such, was known as Boundary Street until the county of Washington beyond its border was annexed to the city in the 1880s. (Courtesy of the Washingtoniana Division, MLK Library.)

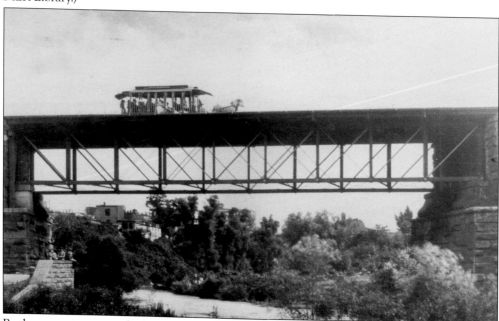

Real estate agents were looking toward the rural Kalorama area for development opportunities, and with the pressures of a burgeoning urban environment, they were promised new utility and transportation systems in exchange for developing the land. The first P Street bridge was built in the early 1880s to connect the Circle with Georgetown and to carry the open commuting cars of the Metropolitan Railroad. (Courtesy of the Washingtoniana Division, MLK Library.)

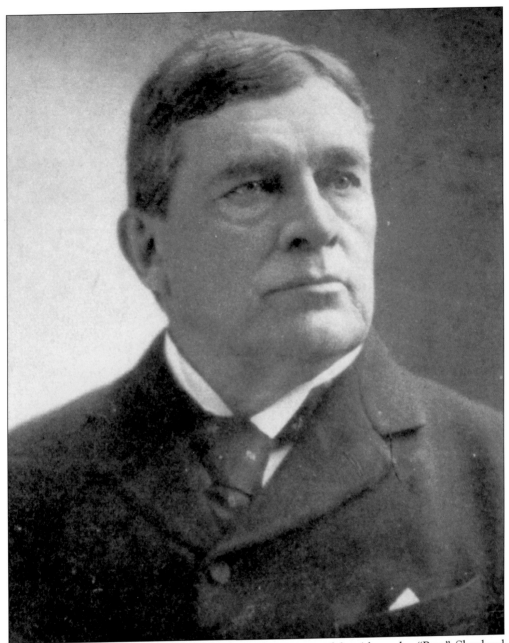

As part of the large-scale, city-wide improvements executed by Alexander "Boss" Shepherd of the board of public works between 1871 and 1873, Massachusetts Avenue was graded and paved as far as Boundary Street, now Florida Avenue. While Shepherd vastly improved the city infrastructure with sewers, gutters, paving, and bridges, his administration was not without corruption and kickbacks that eventually left the city bankrupt. (Courtesy of the Washingtoniana Division, MLK Library.)

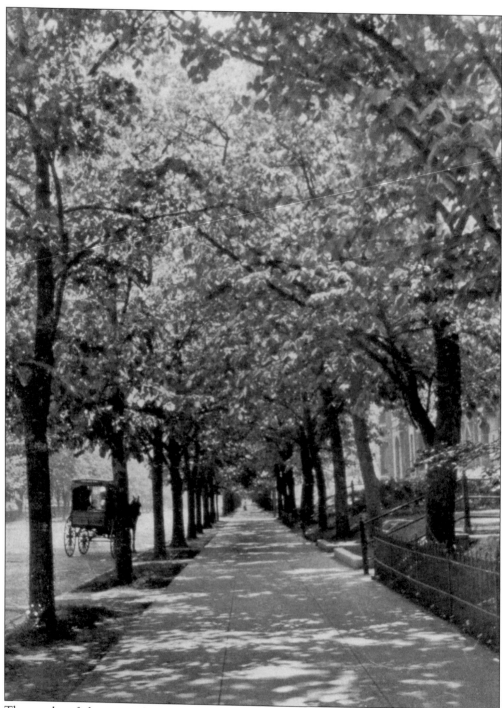

The results of the city-wide improvements made by Boss Shepherd in the 1880s resulted in scenes like this one along Massachusetts Avenue taken in 1913. Large Linden trees planted by Shepherd's administration matured quickly to provide much needed shade, while wide sidewalks and paved streets protected pedestrians from the formerly muddy conditions. (Courtesy of the Washingtoniana Division, MLK Library.)

16

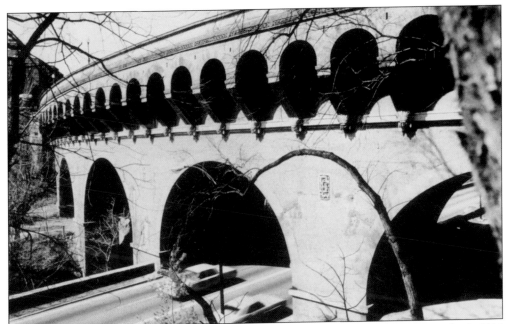

The elegant "Buffalo Bridge," which carries Q Street over Rock Creek Park, was built 1914 to the designs of Glenn and Bedford Brown and provided easy access to the newly developed neighborhoods to the west. The bridge is embellished with a series of masonry heads modeled on Sioux chief Kicking Bear and with large bronze buffalos by sculptor A.P. Proctor. (Courtesy of the Washingtoniana Division, MLK Library.)

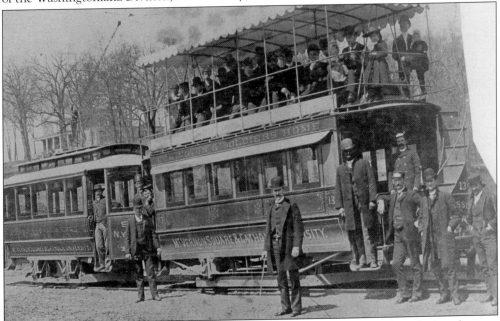

What is today the urban oasis of Dupont Circle remained relatively rural until after the turn of the twentieth century. Residents boarded double-decker trolleys such as this to commute to work and to downtown markets and shopping areas. (Courtesy of the Washingtoniana Division, MLK Library.)

Before 1882, Dupont Circle was known as "Pacific Circle" and was only minimally improved. It was designated "Dupont Circle" by an official act of Congress on February 25th of that year. In the next two decades, large and lavish homes began to be erected around its perimeter, such as these at Massachusetts Avenue and P Streets. (Courtesy of the Library of Congress.)

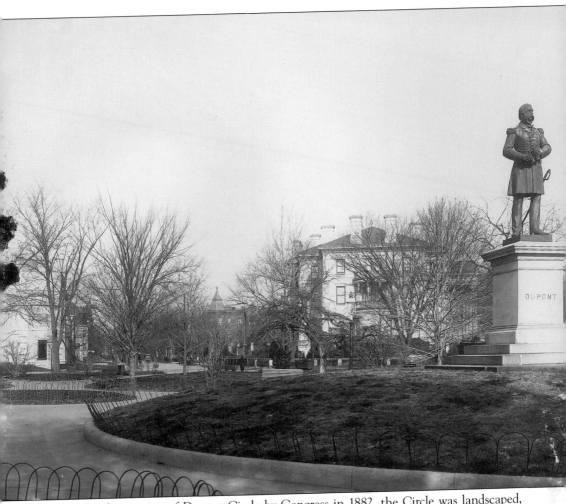

Following the designation of Dupont Circle by Congress in 1882, the Circle was landscaped, and in 1884, a bronze statue of Admiral Samuel F. DuPont by sculptor Launt Thompson was placed in its center. The statue was moved in 1921 to allow for the memorial fountain to be erected as the Circle's focal point, which it is today. (Courtesy of the Library of Congress.)

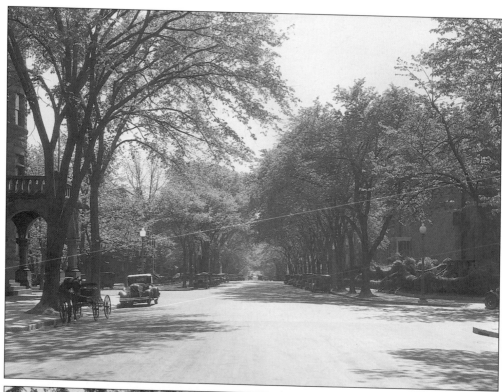

Photographer Theodor Horydczak captured this image of New Hampshire Avenue just south of the Circle in the early 1920s, showing the large, mature trees that Washington was known for, as well as the dichotomy of a horse and carriage and automobile parked next to one another. (Courtesy of the Library of Congress.)

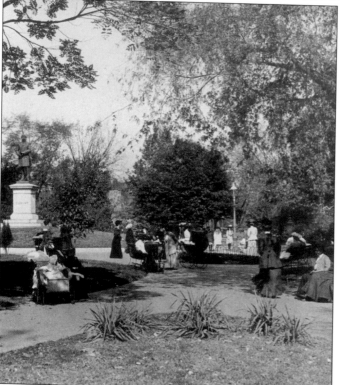

Victorian residents of the Circle enjoy the lush landscaping and the paths that wound through the varied trees and flowers. This image was taken by photographer L.C. Handy about 1900. (Courtesy of the Washingtoniana Division, MLK Library.)

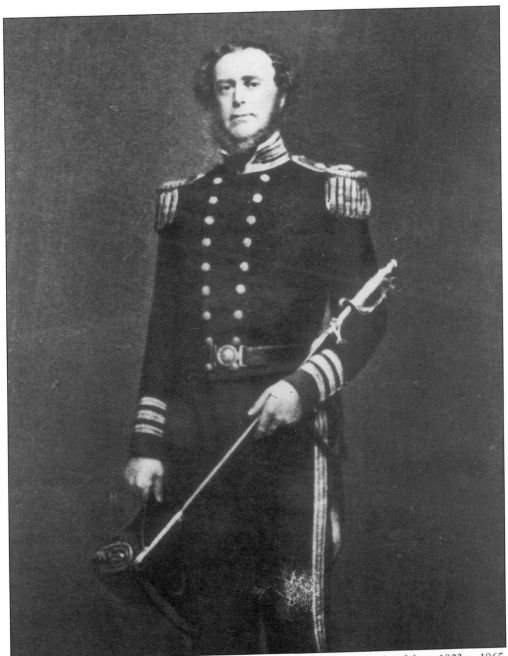

Dupont Circle itself is named for Admiral Samuel Francis DuPont who lived from 1803 to 1865. This image was taken during his naval service in the Civil War. Both the statue, and later the fountain that sits in the Circle today, were dedicated to his memory. (Courtesy of the Library of Congress.)

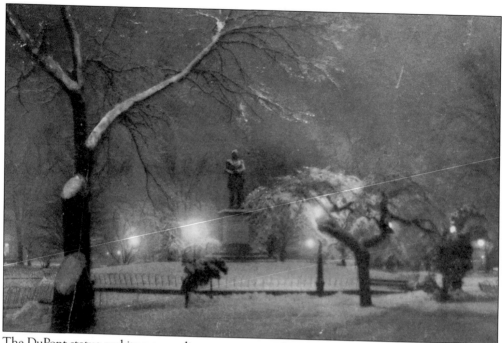

The DuPont statue and its surroundings were captured in this winter 1918 photograph at a time when there were 850 ornamental trees and shrubs in the Circle's 2.25-acre site. (Courtesy of the Washingtoniana Division, MLK Library.)

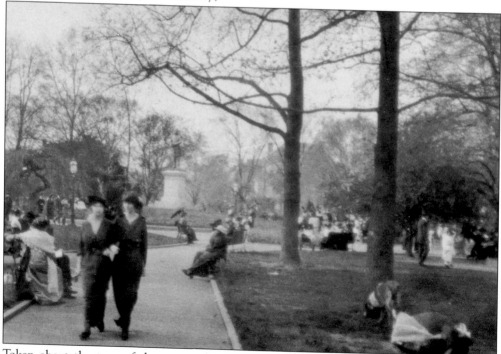

Taken about the turn of the twentieth century, this photograph shows many residents and visitors taking advantage of the 56 cast-iron settees that once existed in the Circle. (Courtesy of the Washingtoniana Division, MLK Library.)

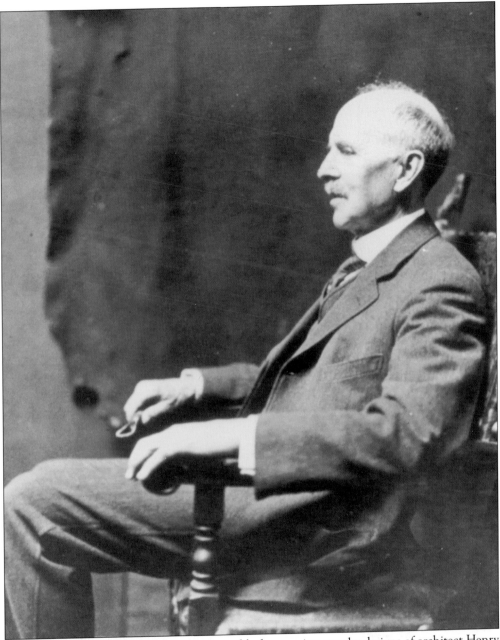

Sculptor Daniel Chester French was responsible for carrying out the designs of architect Henry Bacon for the Dupont Memorial Fountain, which was erected in 1922 at the center of the Circle. French was also witnessing the completion of his Lincoln Memorial on the Mall at the time when his daughter resided close by in the 2000 block of R Street, NW. (Courtesy of the Washingtoniana Division, MLK Library.)

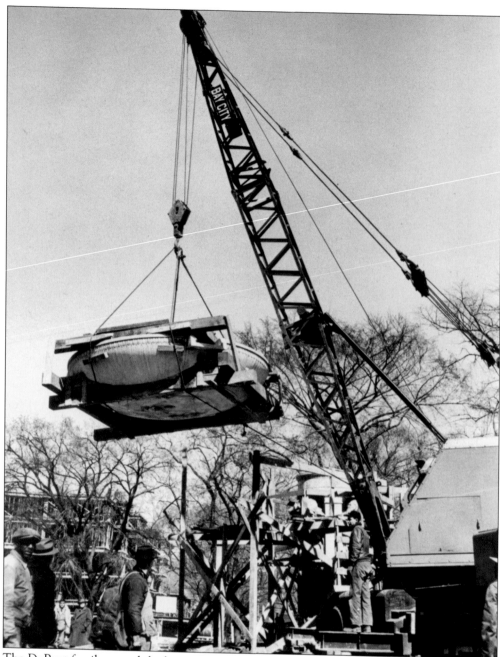

The DuPont family moved the bronze statue of Samuel DuPont to a park in their hometown of Wilmington, Delaware, to make way for the erection of Bacon and French's marble fountain in 1922. Interestingly, water and drainage pipes had been laid for a fountain in 1877, but were not utilized for nearly 50 years. (*Washington Star* photograph by Paul Mc Schmick; courtesy of the Washingtoniana Division, MLK Library.)

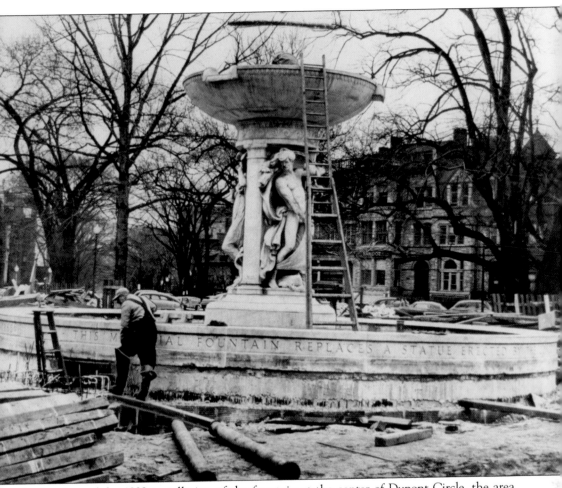

At the time of the 1922 installation of the fountain at the center of Dupont Circle, the area was still residential in nature, with large townhouse mansions surrounding the park itself. (*Washington Star* staff photograph; courtesy of the Washingtoniana Division, MLK Library.)

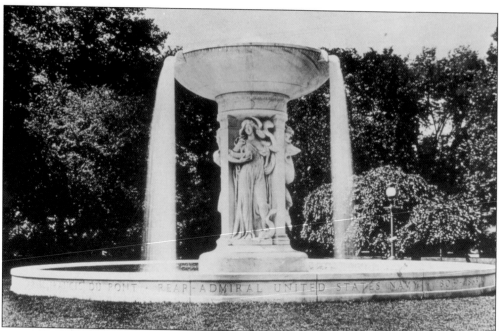

Shortly after its completion, the fountain was surrounded by a grassy area, and the Circle itself was planted with mature trees and thick vegetation. (Courtesy of the Washingtoniana Division, MLK Library.)

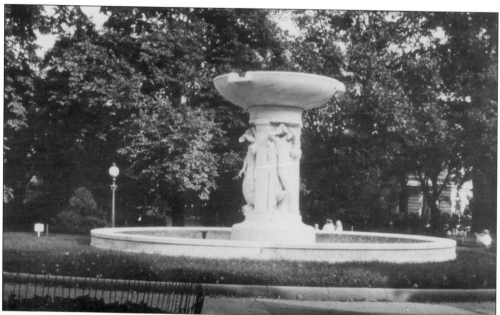

Both the fountain and former statue in Dupont Circle fulfilled city planner Pierre L'Enfant's vision for the city when he wrote in 1791 that "the center of each square will admit of Statues, Columns, Obelisks, or any other ornament such as the different States shall may choose to erect: to perpetuate not only the memory of such individuals whose counsels or Military achievements were conspicuous in giving liberty and Independence to this country." (Courtesy of the Washingtoniana Division, MLK Library.)

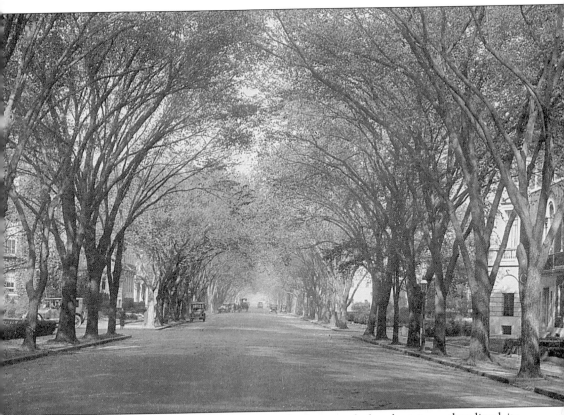

Long known to residents and visitors alike for the large and abundant trees that lined its avenues, Washington's streets, such as New Hampshire Avenue north of the Circle, offered a picturesque respite from hot and humid summers, one of the many long-lasting benefits from Boss Shepherd's civic improvements. (Courtesy of the author's collection.)

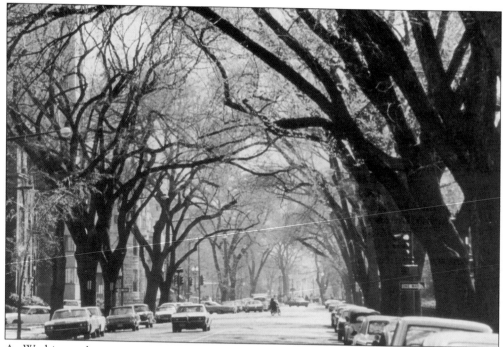

As Washington's streets gave way to more and more traffic, many large trees were removed as avenues and streets were enlarged to accommodate parking prior to the area's designation as a historic district in 1977. (Courtesy of the Washingtoniana Division, MLK Library.)

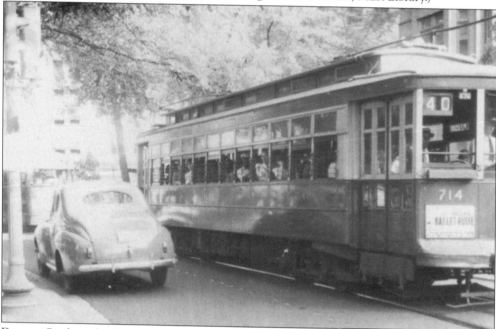

Dupont Circle and other circles in Washington witnessed the competition between increasing traffic and the numerous trolley lines that ran around the Circle, conveying residents from outer suburbs to their workplaces downtown. Here is one such trolley, number 714, in the summer of 1941. (Courtesy of the Washingtoniana Division, MLK Library.)

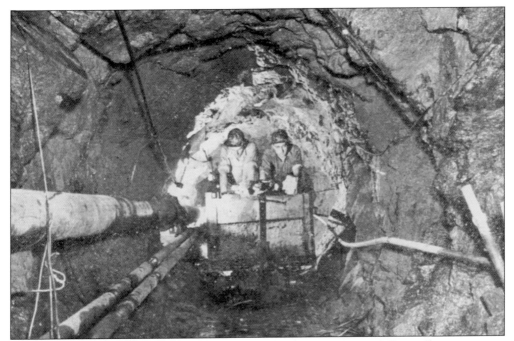

A city municipal publication captured "Leo Butler's crews" in August 1947 installing new storm sewers along Rock Creek Park. They accomplished the task with dynamite blasts and long working days, emerging to the surface only four times per day. (Photograph by Jean Thomas; courtesy of the Washingtoniana Division, MLK Library.)

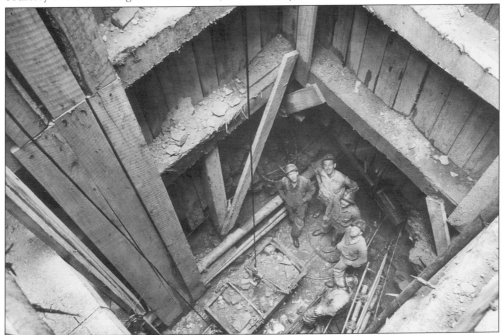

This view down a pit on Twentieth Street in August 1947 shows workers digging a hole for the 6-foot storm sewer pipes being installed 43 feet below traffic on the Circle. (Photograph by Jean Thomas; courtesy of the Washingtoniana Division, MLK Library.)

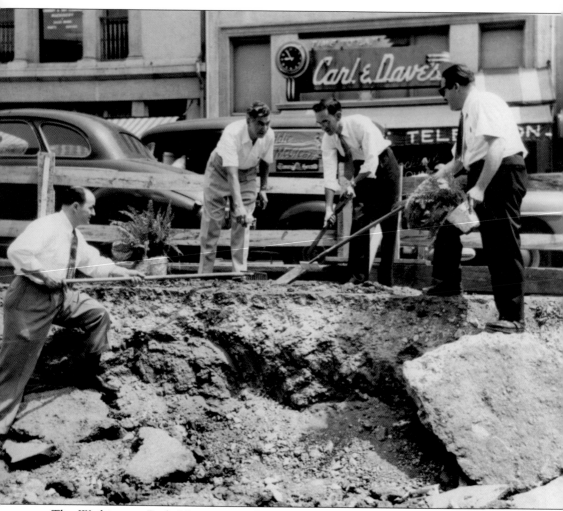

The Washington Daily News captured these Connecticut Avenue merchants attempting to beautify the traffic island in front of their stores in a photograph that ran on May 9, 1949. Pictured, from left to right, are Albert Fiorentino, David Sadel, Carl Clark, and Barry Ackerman. (Courtesy of the Washingtoniana Division, MLK Library.)

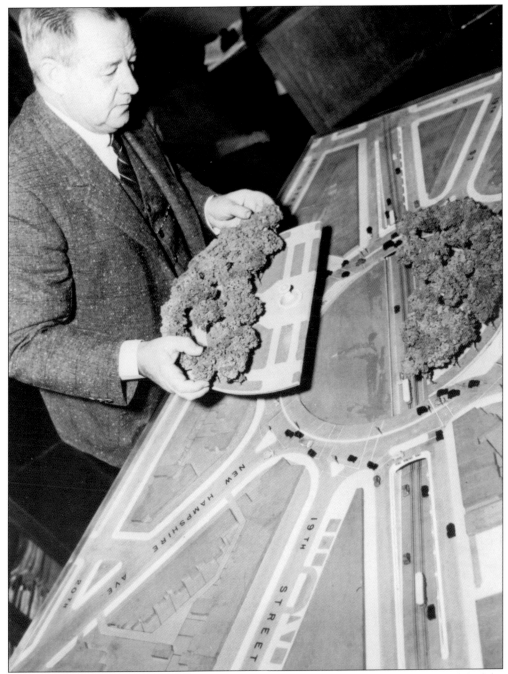

In November 1949, Captain H.C. Whitehurst showed city officials and residents a model of the proposed Dupont Circle automobile underpass that was to be built to provide relief from the increasing through traffic on the Circle. (*Washington Star* photograph by Baker; courtesy of the Washingtoniana Division, MLK Library.)

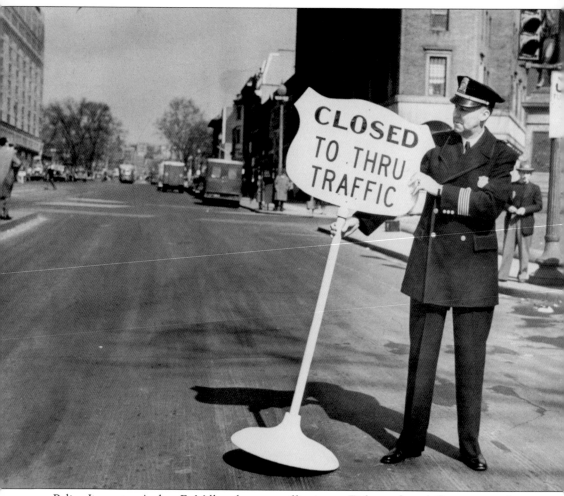

Police Inspector Arthur E. Miller places a traffic sign at Eighteenth and Connecticut Avenue, south of the Circle, signifying the beginning of the underpass construction that would cause massive traffic delays during its erection, which began in 1948. (Courtesy of the Washingtoniana Division, MLK Library.)

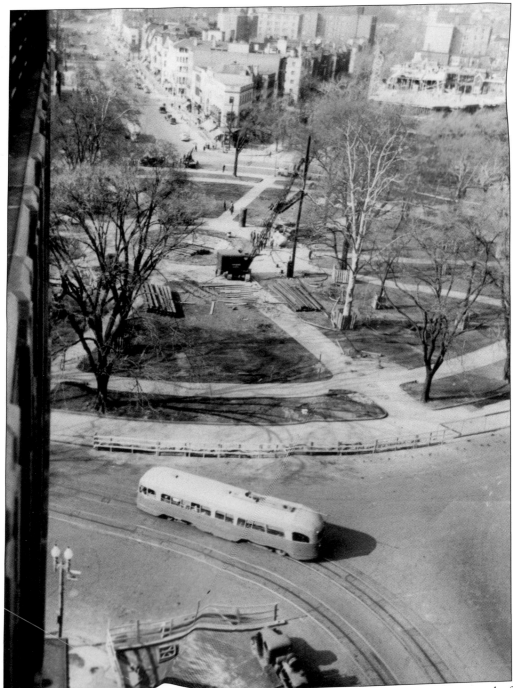

This image from the Dupont Circle building in early 1948 shows the temporary removal of the Dupont memorial fountain during the construction of the trolley underpass. In the background is the construction of the Dupont Plaza Hotel, which was built on the site of the lavish Leiter mansion. (*Washington Star* photograph; courtesy of the Washingtoniana Division, MLK Library.)

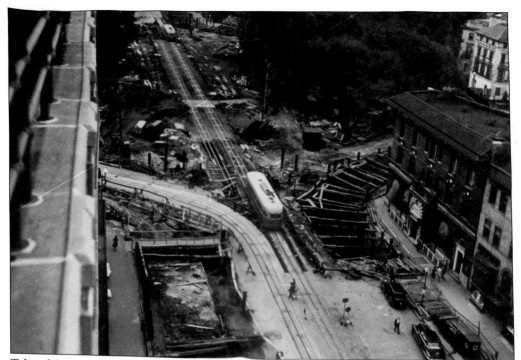

Taken from atop the Dupont Circle building on October 3, 1948, this *Washington Star* photograph shows the diversion of the southbound *Capitol* Transit trolley car, which will eventually travel around and underneath the Circle. (Courtesy of the Washingtoniana Division, MLK Library.)

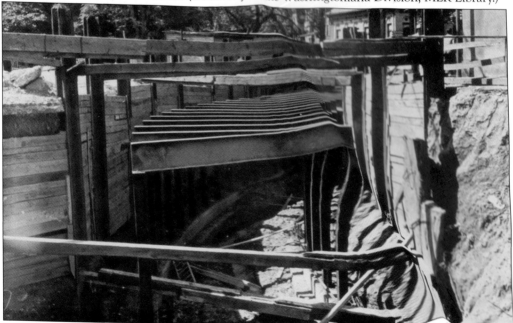

The trolley tunnel underneath Dupont Circle awaits a large pouring of cement when this image was taken on June 7, 1949 for the *Washington Star*. The absence of workers in this picture was due to a carpenters' and laborers' strike. (Courtesy of the Washingtoniana Division, MLK Library.)

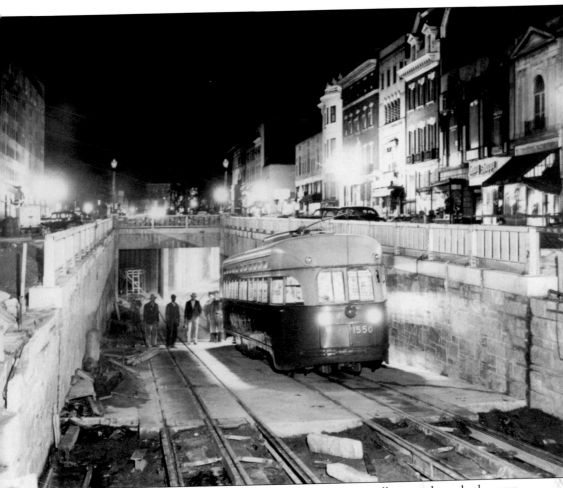

Workers celebrated the entrance of the first Eighteenth Street trolley car through the new tunnel at 5:23 a.m. on November 2, 1949. The photograph ran in that day's edition of the *Washington Star*. (Courtesy of the Washingtoniana Division, MLK Library.)

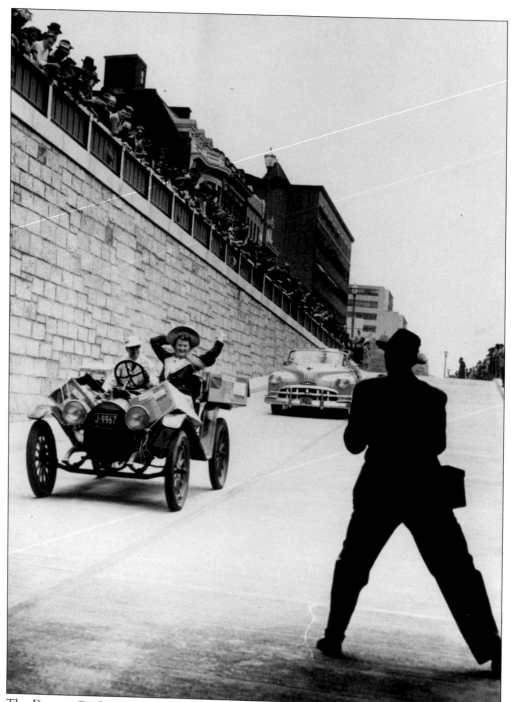

The Dupont Circle vehicular underpass was officially opened on May 16, 1950, when its first vintage automobile passed by scores of onlookers and a photographer for the *Washington Daily News*. (Courtesy of the Washingtoniana Division, MLK Library.)

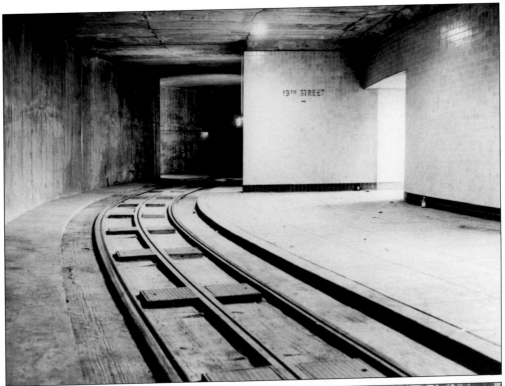

Due to the Metro construction and opening, the streetcar tunnel portion of the Dupont Circle underpass was abandoned in 1975, only 25 years after it was completed. It later had a celebrated, yet failed, revival as the Dupont Underground food court in the 1990s. (*Washington Star* photograph; courtesy of the Washingtoniana Division, MLK Library.)

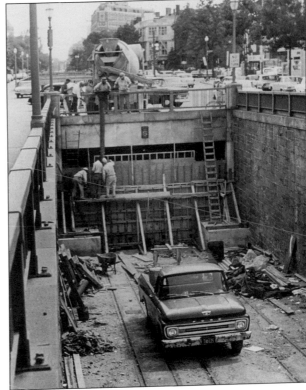

Interestingly, the Dupont Circle underpass was sealed in the summer of 1964—as this image from the August 25, 1964 issue of the *Washington Post* by Dick Darcey illustrates—to provide civil defense cover in the event of a nuclear attack on the nation's capitol. The area was to be sealed and filled with food and supplies for area residents. (Courtesy of the Washingtoniana Division, MLK Library.)

As additional vehicular traffic taxed the neighborhood roads, smaller bridges were replaced, such as this one along Massachusetts Avenue over Rock Creek Park in 1941. Both the old Rock Creek Parkway (at left) and the new roadway (at right) are visible. Workmen used dynamite to blast away the old bridge lying underneath the new overpass. (*Washington Star* photograph; courtesy of the Washingtoniana Division, MLK Library.)

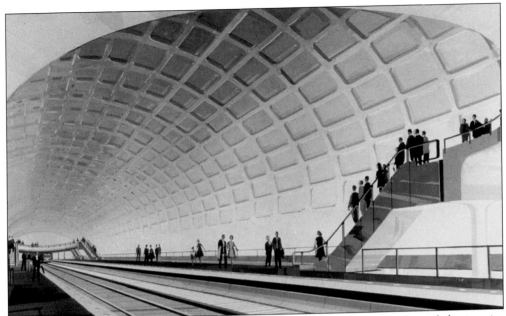

Executed in July 1969, this artist's rendering of the Dupont Circle station showed the interior design of the proposed Metro system. The station would rest 105 feet below ground in an area hewn from solid bedrock. (Courtesy of the Washingtoniana Division, MLK Library.)

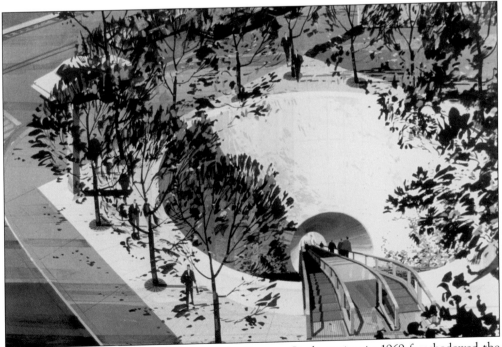

An artist's rendering of the entrance to the Dupont Circle station in 1969 foreshadowed the actual construction of the dramatic structure, with the exception of protective railings to keep pedestrians from falling over the edge into the tunnel. The station was designed to handle 9,000 riders during peak rush hours. (Courtesy of the Washingtoniana Division, MLK Library.)

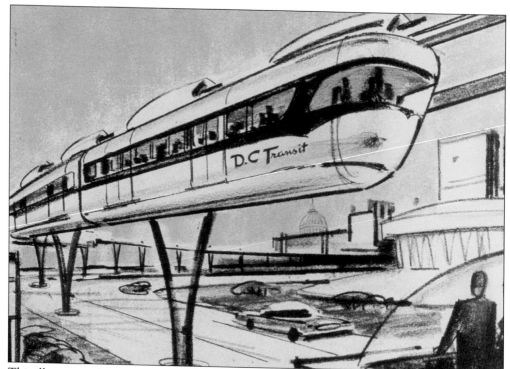

This illustration from the 1969 D.C. Transit Authority's annual report shows how stations such as Dupont Circle would be connected to above-ground stations located outside the city in a Jetson-like monorail system. (Courtesy of the Washingtoniana Division, MLK Library.)

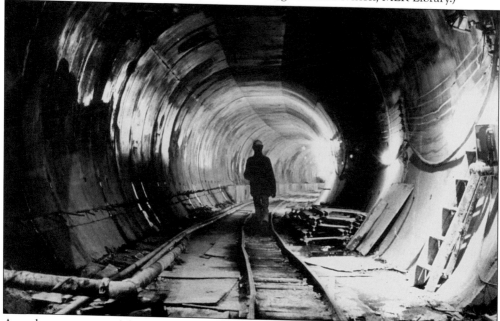

Actual construction of the Dupont Circle Metro station, as seen in this September 1972 image, followed the tunnel excavation by the "Big John Tunneling Machine" utilized by the Transit Authority. (Courtesy of the Washingtoniana Division, MLK Library.)

Two

RESIDENTS AND VISITORS

Throughout its history, Dupont Circle has always been home to a variety of influential, wealthy, and well-known political and business residents, as well as working-class laborers and people of more modest means. Early residents tended to built grand houses in what was then the countryside in the 1870s, and many of the structures have since been torn down. However, Dupont Circle served as Washington's urban social center for many decades starting in the 1880s, with lavish parties and grand dinners served by hostesses throughout the neighborhood. Presidents, congressmen and ambassadors mixed company with mining magnates and newspaper owners to create a dynamic social and cultural center unparalleled in any other American city.

The Dupont Circle neighborhood has also been home to incoming and departing presidents unlike any other community in America. At the close of his administration, President Woodrow Wilson purchased the large, elegant townhouse at 2340 S Street designed by Waddy Wood in 1915. William Howard Taft also owned a house on the Circle. Three future presidents also called the neighborhood home. Then assistant secretary of the navy Franklin Delano Roosevelt came to Washington in 1917 and rented a small townhouse at 2135 R Street until 1920. Warren Harding lived at 2314 Wyoming Avenue from 1917 to 1921 (when he became president) in a house designed by George N. Ray in 1915. Herbert Hoover was brought to Washington, D.C. to serve on the American Relief Board during World War I, and in 1921, he purchased the Thomas Gales House at 2300 S Street that was designed in 1902 by Appleton P. Clark Jr. Hoover lived in the house with his family until his inauguration in 1929 and after leaving the White House from 1933 to 1944.

Dupont Circle continued to attract a diverse residential population throughout its history and even to this day—it is today a place where presidential staffers, best-selling authors, and business owners mingle with college students and young Congressional interns.

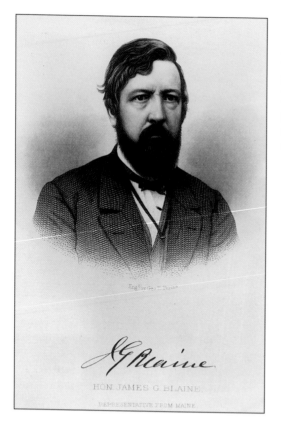

HON. JAMES G. BLAINE.
REPRESENTATIVE FROM MAINE.

Maine senator James G. Blaine was one of the first residents of Dupont Circle when he built his mansion at 2000 Massachusetts Avenue (the building still remains today). He served in many political positions, including Speaker of the House, senator from Maine, U.S. secretary of state, and ran three times as a presidential candidate. (Courtesy of the Library of Congress.)

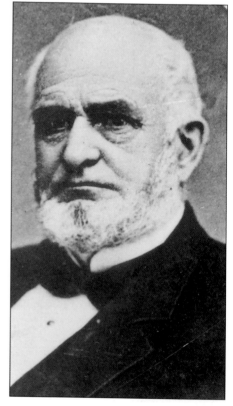

Another early resident of Dupont Circle was Wisconsin senator Philetus Sawyer, who built a stone mansion at the intersection of Connecticut Avenue, R Street, and Nineteenth Street in 1888. It remained there only 33 years and was replaced by the building that now serves as the La Tomate Restaurant. (Courtesy of the Library of Congress.)

Montana senator William Clark also called Dupont Circle his home when he purchased Stewart Castle in 1899. He tore it down two years later, but his plans to build a house in its place went awry and the lot remained empty until the Riggs bank was constructed in 1923. (Courtesy of the Library of Congress.)

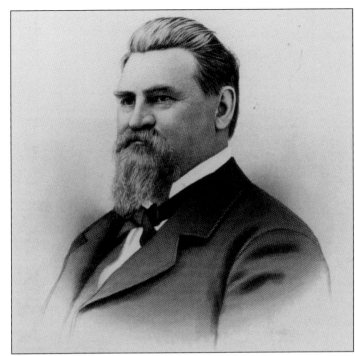

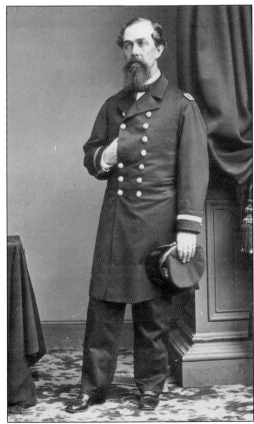

Residing at 1614 Nineteenth Street from 1888 to 1906 was Navy Commander Aaron Konkle Hughes, who had been in charge of the steamer *Water Witch*, gunboat *Mohawk*, and gunboat *Cimarron* during the Civil War. (Courtesy of the Library of Congress.)

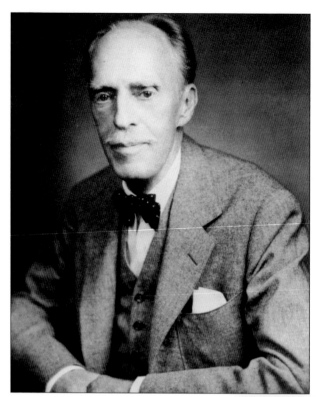

Duncan Phillips created the first museum of modern art in America when he opened up two exhibition rooms in his own house at 1612 Twenty-first Street in 1921, a site that has been expanded and now houses the Phillips Collection. (Courtesy of the Washingtoniana Division, MLK Library.)

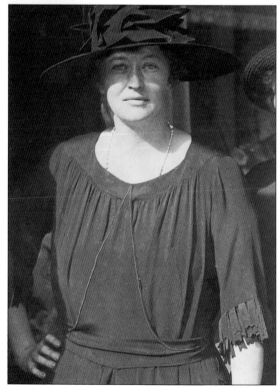

Mrs. J. Leiter, the wife of Chicago department store and real estate tycoon Levi P. Leiter, reigned in Washington society from her mansion on the Dupont Plaza Hotel site, which was first built in 1891. (Courtesy of the Library of Congress.)

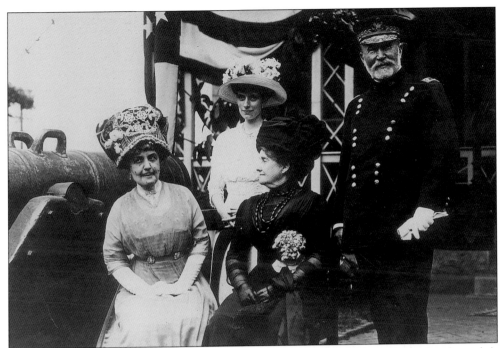

The woman in black is Ida Honore Grant, the wife of Frederick Dent Grant (to the right), the son of famed Civil War general and U.S. president Ulysses S. Grant. Pictured along with unidentified family relatives, Ida Grant built a mansion at 1711 New Hampshire Avenue upon her husband's death in 1912 and lived there until 1939. (Courtesy of the Library of Congress.)

Victorian residents of Dupont Circle enjoy a picture-taking session at the corner of Nineteenth Street; a miniature horse is used as a prop. (Courtesy of the Historical Society of Washington.)

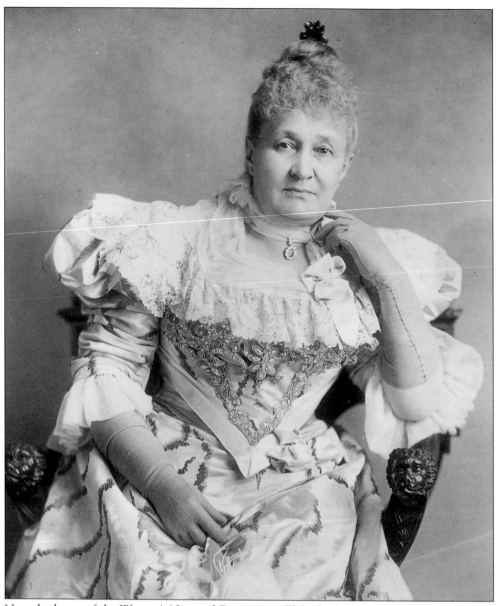

Now the home of the Women's National Democratic Club, the house at 1526 New Hampshire Avenue once belonged to Sarah Adams Whittemore. Prominent in Washington society, she had the house constructed in 1894. (Courtesy of the Library of Congress.)

Alexander Graham Bell was one of Dupont Circle's better known residents—he built a home at 1331 Connecticut Avenue in the summer of 1891. The house featured an annex in which the inventor of the telephone held weekly gatherings of "notable men." (Courtesy of the Library of Congress.)

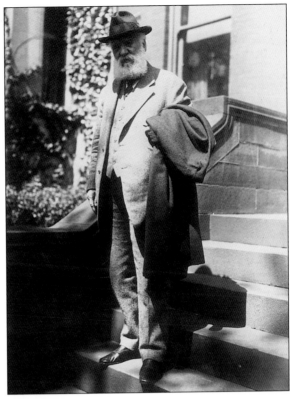

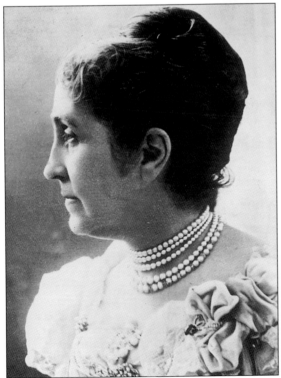

Phoebe A. Hearst, the wife of millionaire George Hearst, was photographed in 1905 while she resided at 1400 New Hampshire Avenue. The couple lived a lavish life here while their son William Randolph Hearst made a fortune in the newspaper business. George had made a fortune owning the world's largest gold mine in South Dakota. (Courtesy of the Library of Congress.)

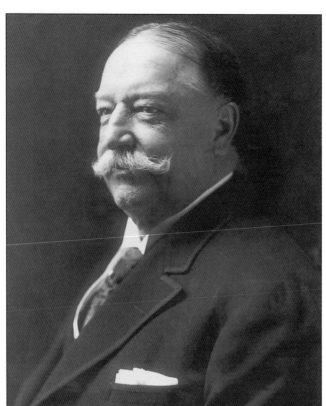

President and Chief Justice William Howard Taft was also a longtime resident of Dupont Circle. (Courtesy of the Library of Congress.)

Mrs. William Howard Taft was photographed in February 1910. Following their time in the White House, the Tafts resided at 2215 Wyoming Avenue from 1921 to 1930. (Courtesy of the Library of Congress.)

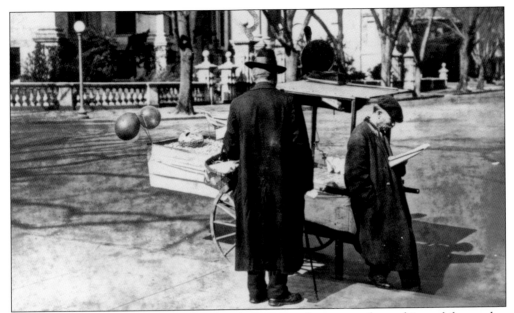

Dupont Circle residents could purchase balloons and popcorn from this mobile vendor, photographed in 1910, at the northern edge of the Circle in front of the Leiter mansion. (Courtesy of the Historical Society of Washington.)

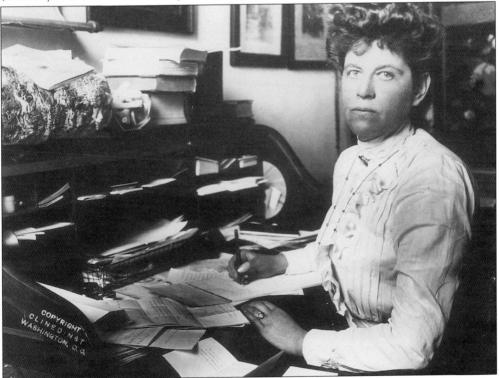

Mabel Boardman resided at 1801 P Street when she helped organize and direct the American Red Cross in the early twentieth century. Her mansion later became the Iraqi Embassy and has been closed since the Persian Gulf War in 1991. (Courtesy of the Library of Congress.)

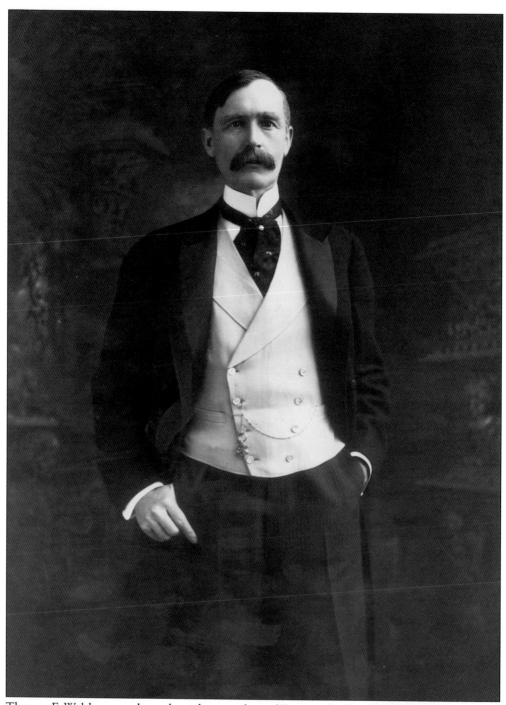

Thomas F. Walsh was perhaps the richest resident of Dupont Circle when he had his imposing, 60-room mansion built at 2020 Massachusetts Avenue at a cost of $800,000. A penniless immigrant in 1869, Walsh later owned the Camp Bird gold mine in Colorado, which he sold in 1903 for $43 million dollars. (Courtesy of the Library of Congress.)

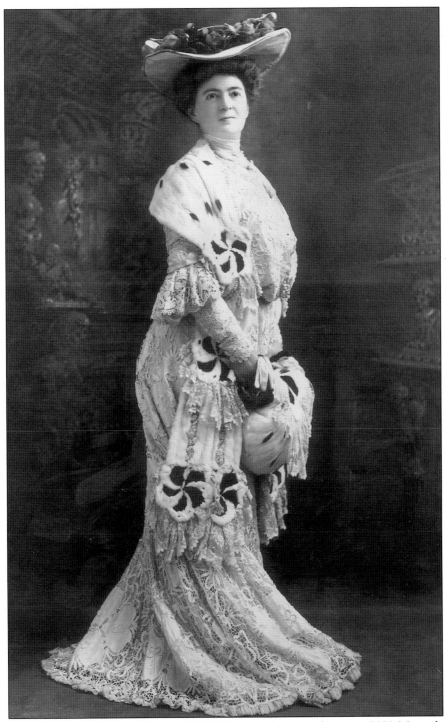

Evalyn Walsh, the daughter of Thomas F. Walsh, split her time between 2020 Massachusetts Avenue and Friendship, the family's country estate on Wisconsin Avenue. She married newspaper magnate Edward Beale McLean of the Washington Post family and was the last private owner of the infamous Hope Diamond. (Courtesy of the Library of Congress.)

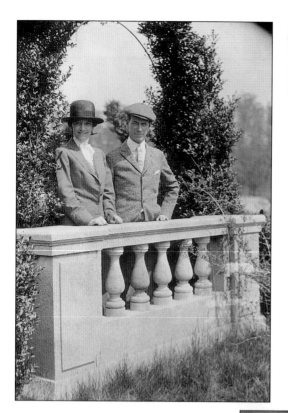

Joseph Medill McCormick and his wife, Ruth, resided at 1706 New Hampshire Avenue while he served as a senator from Illinois from 1918 to his suicide in 1925. (Courtesy of the Library of Congress.)

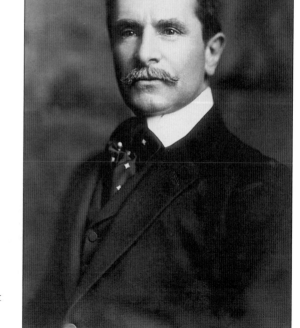

Perry Belmont, a congressman from New York and later an ambassador to Spain, built an imposing mansion at 1618 New Hampshire Avenue in 1909 at a cost of $1.5 million. The Belmont family spent their summers, however, at the "Elms" in Newport, Rhode Island. (Courtesy of the Library of Congress.)

Harriet Lothrup Lutrell, the daughter of Alvin Mason Lothrup, founder of the Woodward and Lothrup department store chain, was active in Washington society during the time she resided at the 40-room mansion at Connecticut Avenue and Columbia Road. (Courtesy of the Washingtoniana Division, MLK Library.)

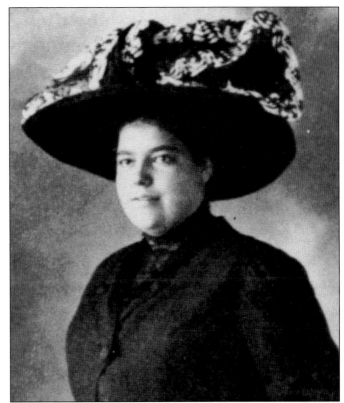

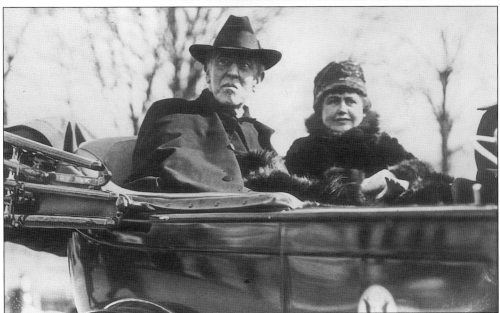

President Woodrow Wilson and his wife, Edith Bolling Galt, were photographed in 1920, five years after they married. A widow of the proprietor of a still-operational jewelry store that bears her name, Edith had resided at 1308 Twentieth Street for many years before she married Wilson in 1915. (Courtesy of the Library of Congress.)

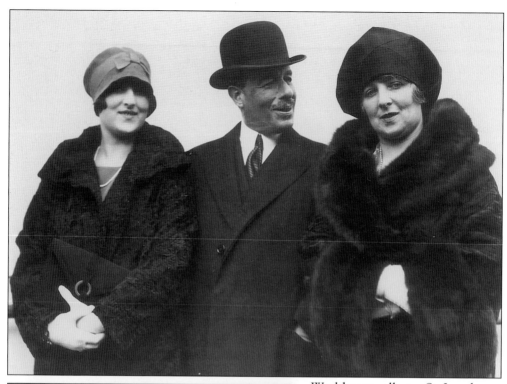

Wealthy art collector Sir Joseph Duveen was photographed with his wife and daughter Dorothy in 1926. He rented a lavish apartment in the McCormick Apartment building at 1785 Massachusetts Avenue in 1936 and filled it with $21 million worth of paintings that eventually established the basis for the National Gallery of Art. (Courtesy of the Library of Congress.)

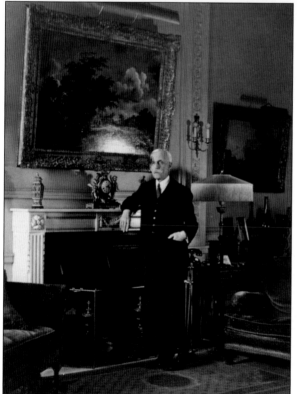

Another famous and wealthy resident of the McCormick Apartment building was Andrew W. Mellon, pictured here inside his lavish apartment. (Courtesy of the Historical Society of Washington.)

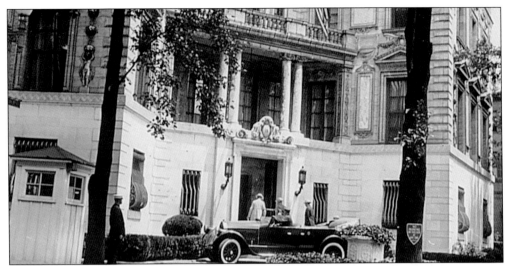

Charles A. Lindbergh is seen visiting the Patterson House at 15 Dupont Circle in 1927, following his famous solo flight over the Atlantic Ocean. He was a house guest here, as were President Calvin Coolidge and his wife, who stayed at the home that year while the White House was being refurbished. (Courtesy of the Historical Society of Washington.)

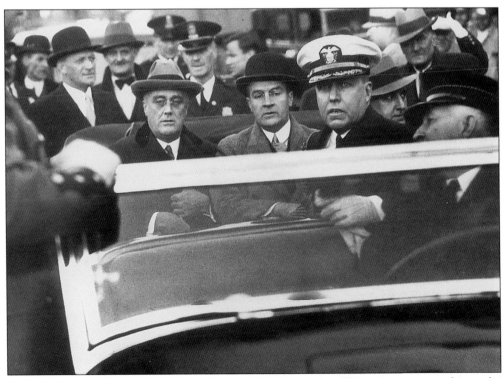

President Franklin D. Roosevelt was photographed during one of his sojourns to worship at the St. Thomas Episcopal Church at the corner of Eighteenth and Church Streets. (Courtesy of the Library of Congress.)

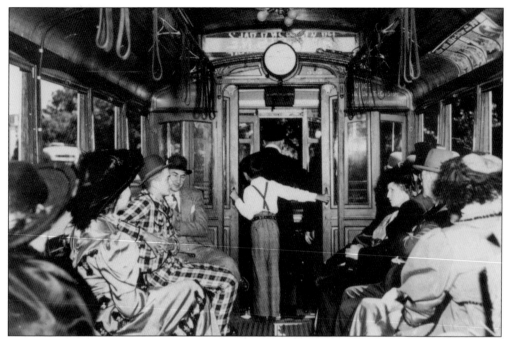

Most residents of Dupont Circle commuted to work and shops via one of the many wooden trolley's that ran through, around, and eventually, underneath the circle. (Courtesy of the Historical Society of Washington.)

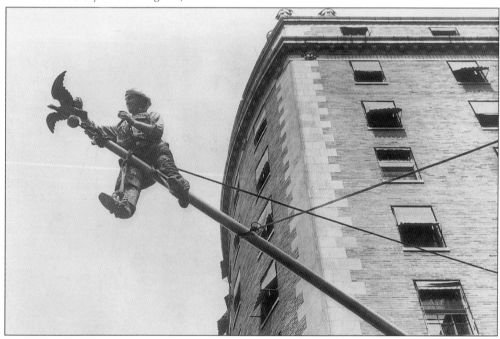

Steeplejack Joe White is seen re-gilding the eagle on the Mayflower Hotel flagpole in 1932. White, who was 6'3" and 250 pounds was said to have been the heaviest man in the hazardous profession, often bending the poles precariously over the sidewalk. (Courtesy of the Library of Congress.)

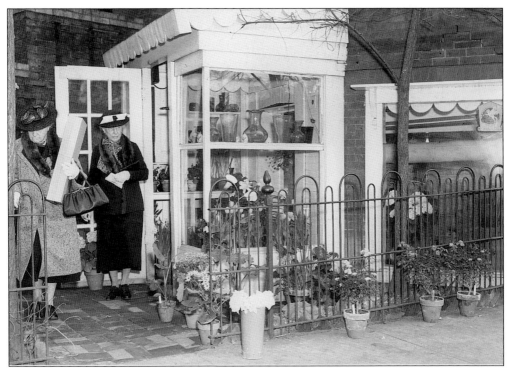

Dupont Circle residents could purchase flowers in the spring of 1942 from this tiny flower shop tucked between two of the townhouses located on the Circle. (Courtesy of the Library of Congress.)

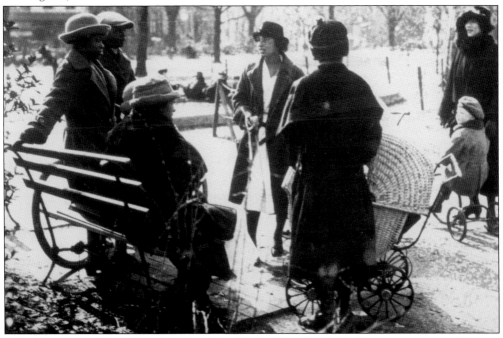

African-American nurse maids gathered in the Circle in the 1930s for conversation and gossip. (Courtesy of the Historical Society of Washington.)

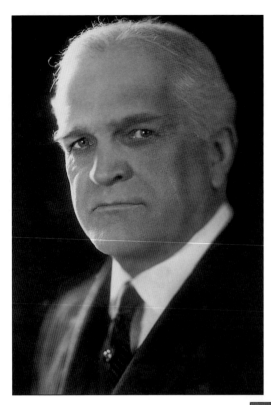

Author and Reverend Bishop William F. McDowell was one of Dupont Circle's residents; he lived at 2107 Wyoming Avenue from 1923 to 1931 while heading the Methodist Episcopal Church on Capitol Hill. (Courtesy of the Library of Congress.)

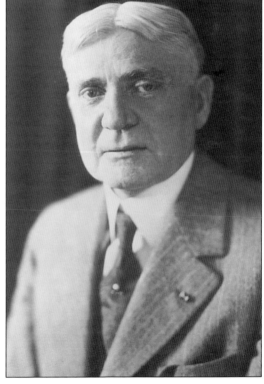

Another resident of 2107 Wyoming Avenue was Bishop Edwin H. Hughes, who lived there from 1932 to 1939. He became a bishop in 1908, just 16 years after graduating from the Boston School of Theology. He was the youngest person to hold the title in the 60 years prior. (Courtesy of the Library of Congress.)

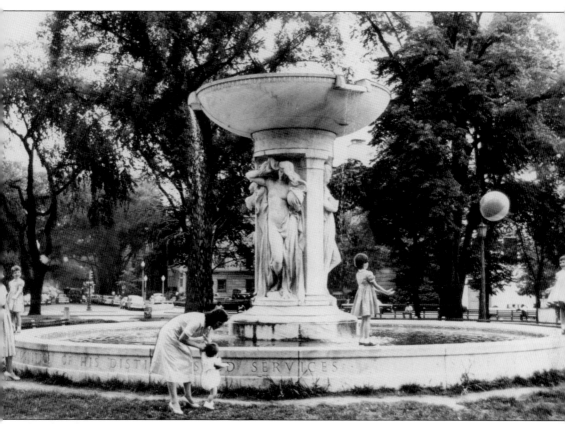

Photographed for the *Washington Star* on August 4, 1957 was the wife of the first secretary of the Belgian Embassy, Madame Hovard (at left). She is pictured here with, from left to right, her daughter Anne (age five), nursemaid Teresa with one-year-old Jacques, Caroline (age seven), and Agnes (age nine). (Courtesy of the Washingtoniana Division, MLK Library.)

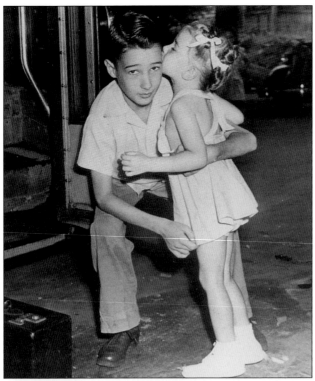

Dupont Circle resident Robert Collins gets a kiss from his sister Shirley Ruth on July 2, 1946 as he leaves home—2228 R Street—for Metropolitan Police Boys Club camp in Scotland, Maryland. (Courtesy of the Washingtoniana Division, MLK Library.)

Members of the Washington Boys Club board a bus on Dupont Circle before heading to summer camp in Scotland, Maryland in 1947. (Courtesy of the Washingtoniana Division, MLK Library.)

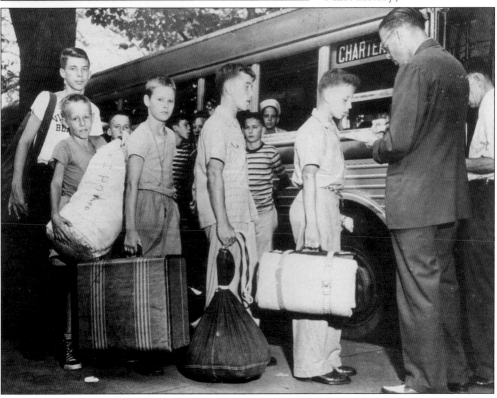

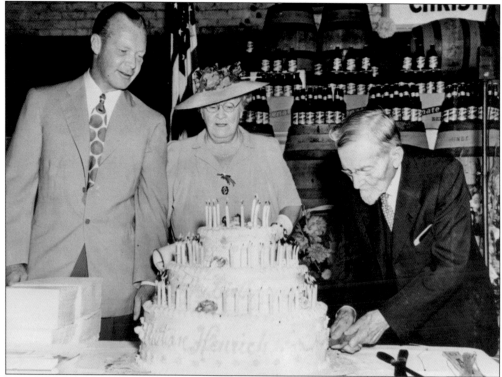

Resident and brewery owner Christian Heurich celebrates his 100th birthday on September 12, 1942, with his wife and son Christian Jr. (Courtesy of the Washingtoniana Division, MLK Library.)

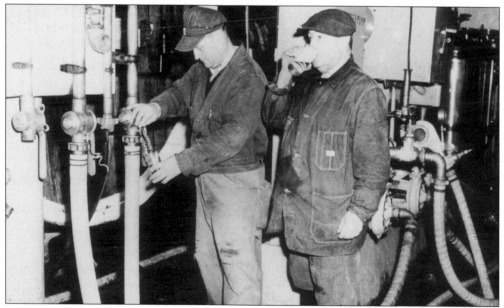

William Weiman fills a glass of beer while John Fischbach drinks a brew at Heurich's Lager Beer Brewery and Tavern, located at 1229 Twentieth Street from 1872 until it was destroyed by fire in 1892. (Courtesy of the Washingtoniana Division, MLK Library.)

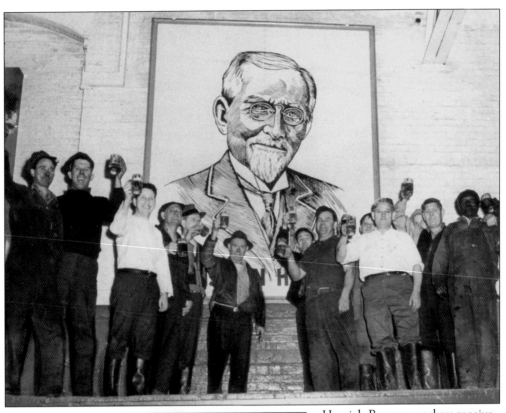

Heurich Brewery workers receive their daily 4 p.m. beer in front of a mural of the company's founder, Christian Heurich. (Courtesy of the Washingtoniana Division, MLK Library.)

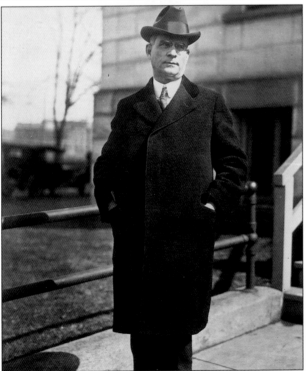

Ira E. Bennett was photographed on the day of his testimony before the Senate during the Teapot Dome scandal on March 7, 1924. He and his wife, Mabel, purchased 1614 Nineteenth Street in 1912. Bennett had started as a *Washington Post* editorial writer in 1905 and served as its influential editor from 1908 to 1933. (Courtesy of the Library of Congress.)

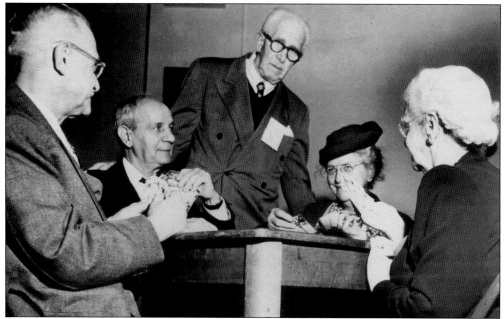

Jewish Community Center members of the Golden Age Club play cards at the center's game room on Sixteenth Street in 1952. Pictured from left to right are Max Norman, David Notes, Charles Scheff, Annabel Wheeler, and Ida Levich. (Courtesy of the Washingtoniana Division, MLK Library.)

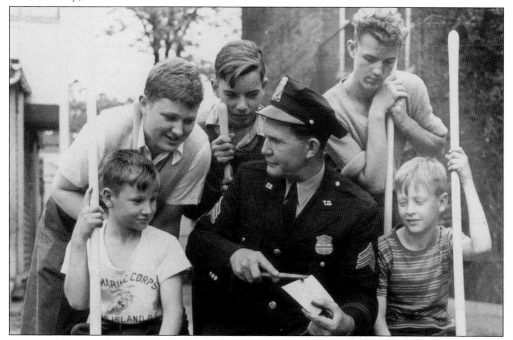

Sergeant Forrest L. Biaswanges shows Metropolitan Police Boys Club members how to sharpen a hoe in 1948. Pictured from left to right are Charles Johnson, Paul Spangler, Alvin Gwice, Russell Linthicum, and Bill McDaniels. (Courtesy of the Washingtoniana Division, MLK Library.)

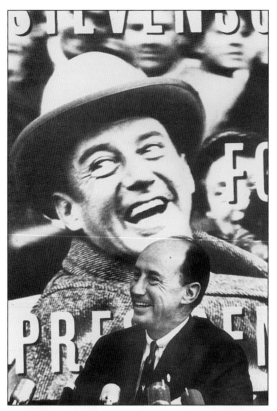

Senator Adlai E. Stevenson rented a house at 1904 R Street from 1941 to 1943 when he worked as an assistant to Naval Secretary Frank Knox. Stevenson later ran for president in 1952 and 1956, when this image was taken, and served as the U.S. ambassador to the United Nations. (Photograph by Frank Scherschel; courtesy of the Library of Congress.)

Washington Star photographer Chinn captured an unidentified sleeping man in the Circle for the March 14, 1957 edition of the newspaper. (Courtesy of the Washingtoniana Division, MLK Library.)

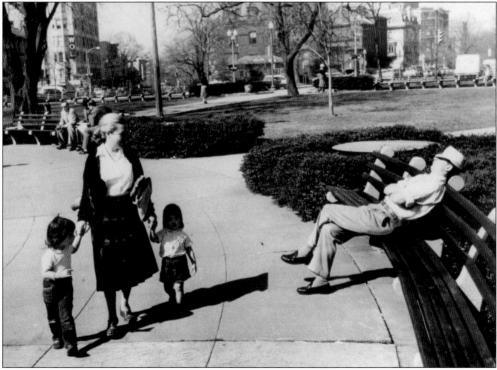

Three

RESIDENTIAL ARCHITECTURE

Though Dupont Circle is now a compact urban residential and commercial neighborhood, the origins of residential architecture in the area began in the early nineteenth century with the construction of large country estates. Washington, D.C. was then a small city with a downtown near the White House a mile to the south and the port city of Georgetown to the west. The area around what was then known as Pacific Circle was home to prominent and wealthy land owners, who situated their homes amid large agricultural fields and orchards at the city's edge.

The choice area in which early Victorians constructed elegant townhomes in the 1870s in Washington was Logan Circle to the west, which quickly filled with grand and impressive residences. However, as the Industrial Revolution and the lack of income tax enriched the city's population combined with savvy real estate speculators and city infrastructure improvements, Dupont Circle quickly became the place for the elite to express their wealth. Massive homes of marble and stone, unmatched by any seen in the city before, were built around the Circle and along Massachusetts and New Hampshire Avenues.

Nationally known architectural firms such as Hornblower and Marshall and Stanford White joined with the local architects of the wealthy to create masterpieces in the neighborhood. Townhomes for those of more modest means were constructed individually with care and quality materials, or as architect and builder Franklin Schneider preferred, in rows of 60 or 70 built simultaneously. Many of the grand homes around the Circle gave way in the 1970s to office buildings, but a few remain to join the thousands of townhomes and rowhouses carefully restored and lining the streets of Dupont Circle.

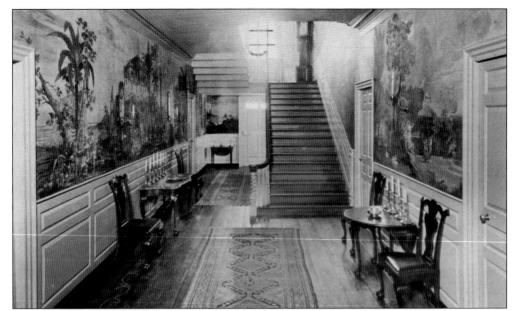

In 1937, George Morris had the King-Hooper House of Danvers, Massachusetts, dismantled and re-erected at 2401 Kalorama Road. "The Lindens," as it is called today, was built in 1754 and thus has the distinction of being the oldest house in Dupont Circle. (Courtesy of the Washingtoniana Division, MLK Library.)

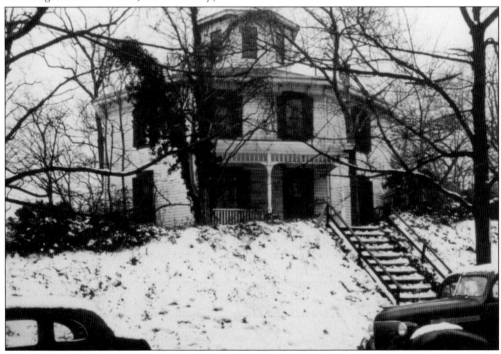

Built in 1865, the house at 1830 Phelps Place was the last of only five octagonal houses built in Washington. It was erected by two patent office clerks and brothers William and Edward Beeb. The home was owned by the Tuttle family for 83 years before being demolished in 1950. (Courtesy of the Washingtoniana Division, MLK Library.)

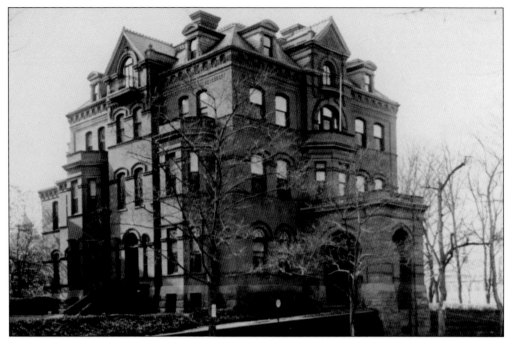

Two Patten sisters built this lavish mansion at 2122 Massachusetts Avenue in the early 1880s, when the area was still rural in nature. (Courtesy of the Washingtoniana Division, MLK Library.)

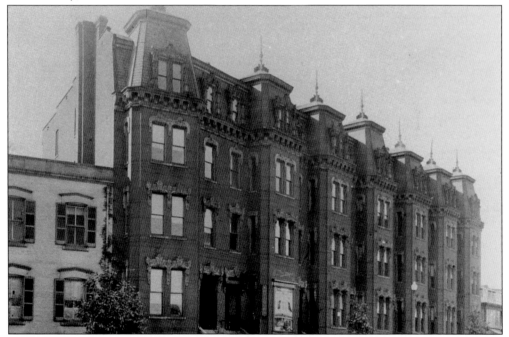

Philip's Row at 1302 to 1314 Connecticut Avenue was built in 1878 and was considered one of the city's most fashionable addresses. The handsome homes, designed by architects Adolph Cluss and Paul Schulze, were torn down following World War II. (Courtesy of the Washingtoniana Division, MLK Library.)

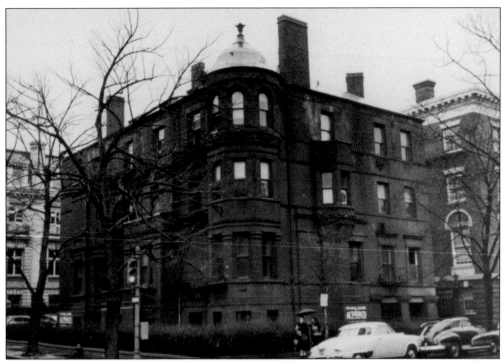

Major A.E. Bates built this large house at 1775 N Street in 1883. President Lincoln's son Robert Todd Lincoln owned it until 1918. (Courtesy of the Washingtoniana Division, MLK Library.)

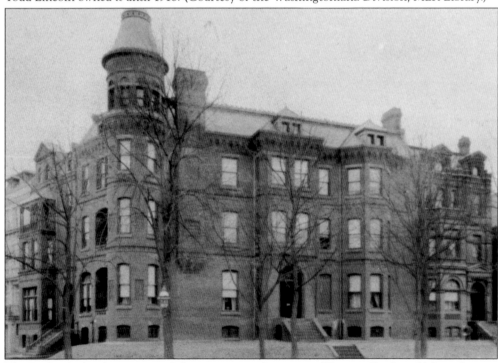

The Fairbanks family constructed this mansion at the corner of Dupont Circle and Massachusetts Avenue in the early 1880s. (Courtesy of the Washingtoniana Division, MLK Library.)

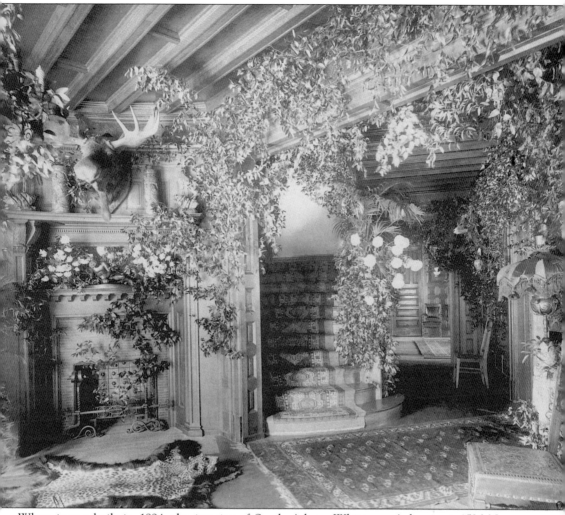

When it was built in 1894, the interior of Sarah Adams Whittemore's house at 1526 New Hampshire Avenue featured decorations of the day including enormous creeping plants, a leopard-on-bear-skin rug, and a moose head. (Courtesy of the Library of Congress.)

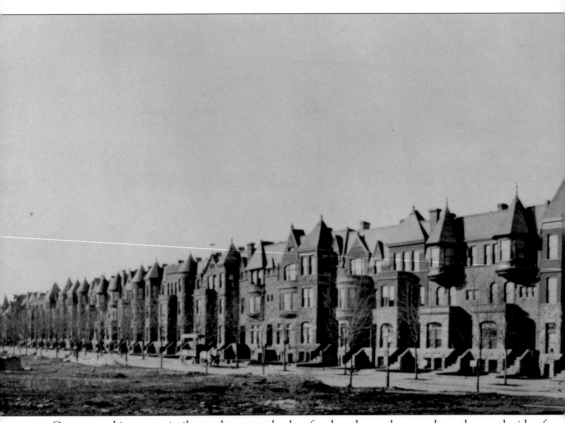

Constructed in a way similar to the new suburbs of today, the rowhouses along the north side of the 1700 block of Q Street were built simultaneously by developer and prolific architect Thomas Franklin Schneider between 1889 and 1892. Schneider paid $175,000 for the row of lots along

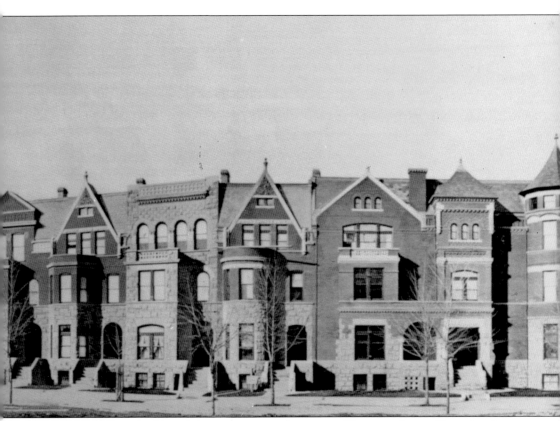

the street in 1889 and sold each house in a speculative way. He was only age 31 at the time these homes were built and would design over 2,000 buildings in Washington during his career. (Courtesy of the Historical Society of Washington.)

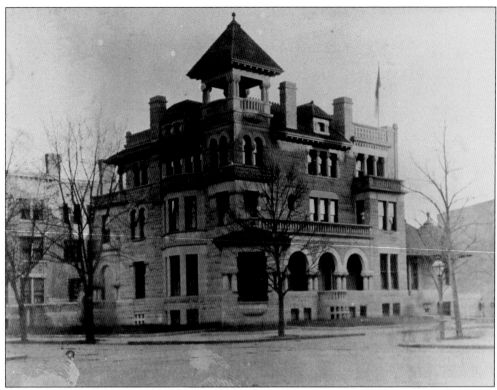

Built by Thomas Franklin Schneider in 1890, his own 60-room mansion of granite once stood at the corner of Eighteenth and Q Streets. It later served as the Chinese Legation until it was demolished in 1957. (Courtesy of the Washingtoniana Division, MLK Library.)

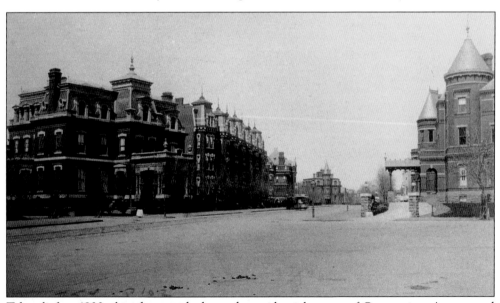

Taken before 1900, this photograph shows the residential nature of Connecticut Avenue and the British Legation at left, built in 1872; Phillips Row, built in 1878; and in the background, Stewarts Castle on Dupont Circle. (Courtesy of the Washingtoniana Division, MLK Library.)

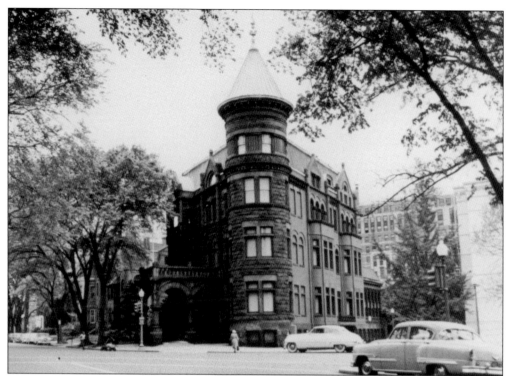

German beer brewer Christian Heurich built himself this large mansion at 1307 New Hampshire Avenue from 1892 to 1894. It was designed by John Granville Meyers, and now houses the Washington Historical Society. (Courtesy of the Washingtoniana Division, MLK Library.)

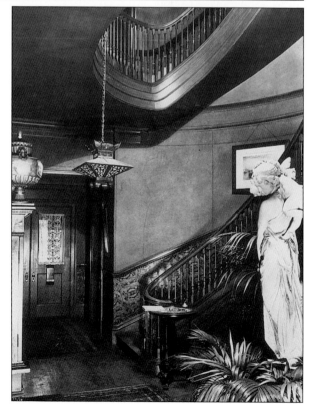

The interior staircase of Alexander Graham Bell's house at 1331 Connecticut Avenue was photographed in 1923 by Gilbert Grosvenor. (Courtesy of the Library of Congress.)

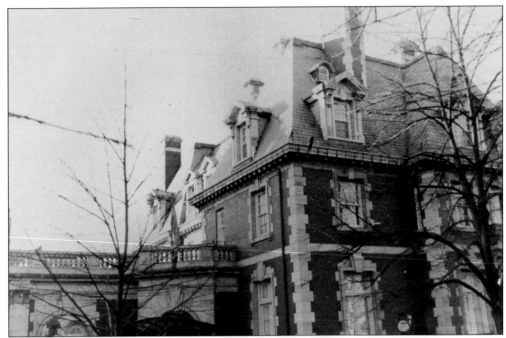

Architects Bruce Price and Jules Henri de Sibour designed this house for Thomas T. Gaff in 1904. Located at 1520 Twentieth Street, it now serves as the Colombian Embassy. (Courtesy of the Washingtoniana Division, MLK Library.)

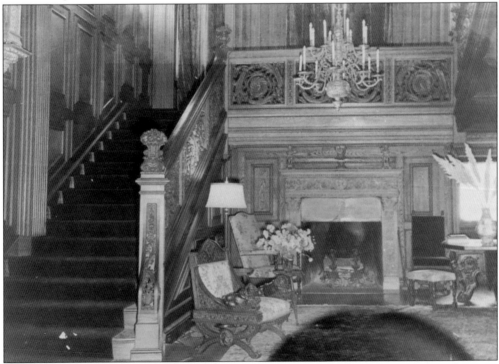

In interior of the Thomas Gaff house is an exercise in exotic wood carving, including the main staircase, pictured here in 1945. (Courtesy of the Washingtoniana Division, MLK Library.)

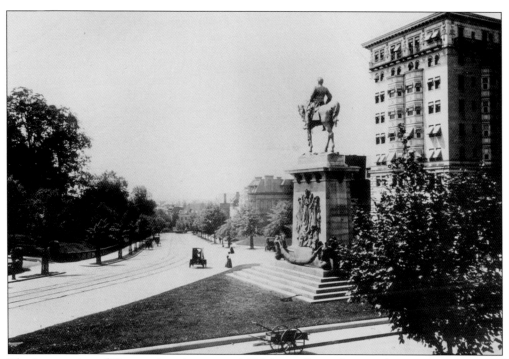

The intersection of Connecticut Avenue and California Street features the equestrian statue of Civil War major general George B. McClellan, pictured here just two years after its installation in 1907. The Highlands Apartment house was one of the first luxury residences built in the city. (Courtesy of the Washingtoniana Division, MLK Library.)

This fine home at 1401 Sixteenth Street at the corner of O Street was built for James S. Sherman in the 1880s. (Courtesy of the Washingtoniana Division, MLK Library.)

Joseph Coerton Hornblower of the architectural firm Hornblower and Marshall was a favorite architect of Dupont Circle citizens, designing dozens of mansions for the area's elite in the 1890s and early 1900s. (Courtesy of the Library of Congress.)

Built between 1902 and 1905, the Larz Anderson house at 2118 Massachusetts Avenue was the work of Boston architects Arthur Little and Herbert Brown. It now serves as the headquarters for the Society of the Cincinnati. (Courtesy of the Library of Congress.)

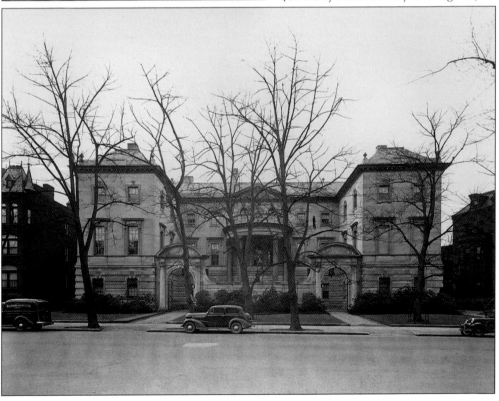

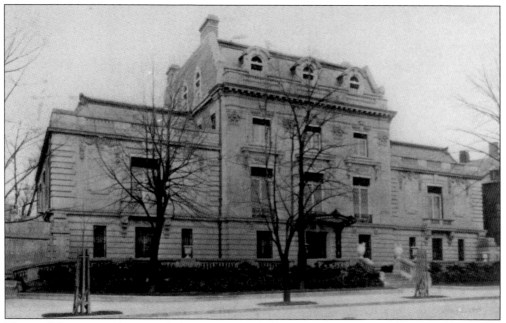

The well-known architectural firm Carrere and Hastings designed this grand mansion for Richard H. Townsend in 1901, utilizing a smaller townhouse in the center block that had been built for wealthy resident Curtis J. Hillyer. (Courtesy of the Washingtoniana Division, MLK Library.)

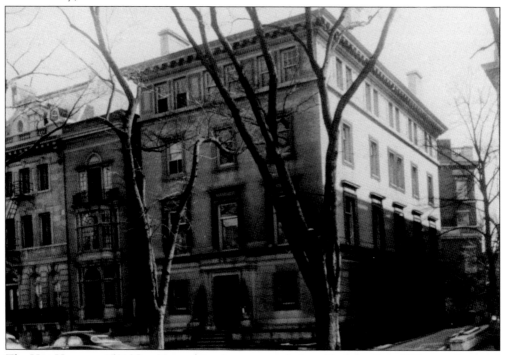

The Hitt House at 1501 New Hampshire Avenue was designed by John Russell Pope and erected in 1908. It was built by the widow of Congressman Robert R. Hitt and was demolished in 1970. (Courtesy of the Washingtoniana Division, MLK Library.)

The cast-iron canopies of the townhouses located at 2219 to 2123 R Street were captured in this snow scene during the 1940s. (Courtesy of the Washingtoniana Division, MLK Library.)

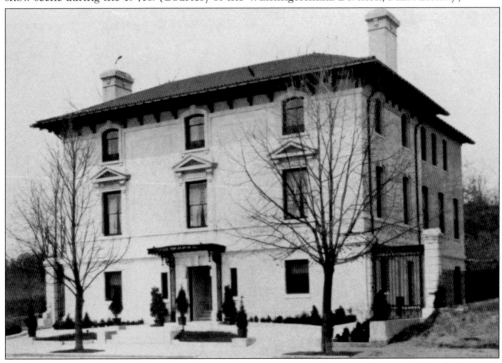

This residence at 2253 R Street was designed by the local architectural firm of Wood, Donn & Deming and was featured in a leading architectural journal when it was completed. (Courtesy of the Washingtoniana Division, MLK Library.)

This house was once located at 1785 Massachusetts Avenue and was built for Beldon Noble. It was replaced by the McCormick Apartment building in 1915. (Courtesy of the Washingtoniana Division, MLK Library.)

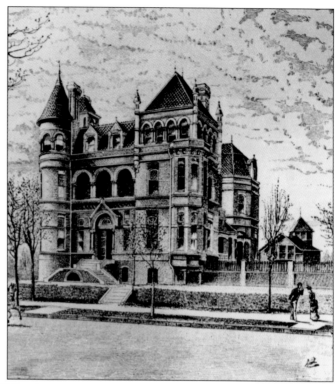

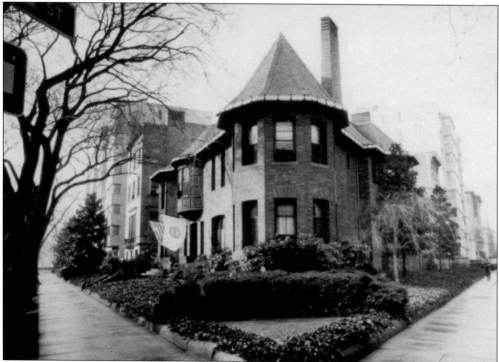

Sarah Adams Whittemore hired architect Harvey Page to design her unusual corner home at 1526 New Hampshire Avenue in 1892. (Courtesy of the Washingtoniana Division, MLK Library.)

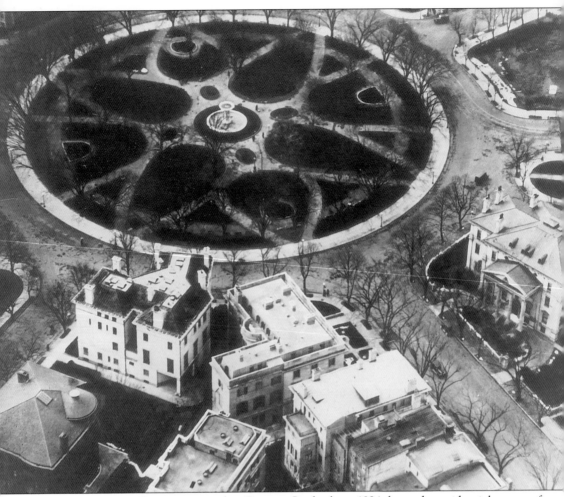

This aerial view of homes surrounding Dupont Circle about 1924 shows the residential nature of the park before many of the homes were demolished to make way for large commercial buildings in the 1970s. Despite their large size and prominent occupants, the houses were built surprisingly close to one another. (Courtesy of the Library of Congress.)

These houses covered with wisteria and Japanese ivy at 1, 2, and 3 Dupont Circle were photographed by F.W. Smith in 1900, when their site was proposed as a location for the National Gallery of History and Art. (Courtesy of the Washingtoniana Division, MLK Library.)

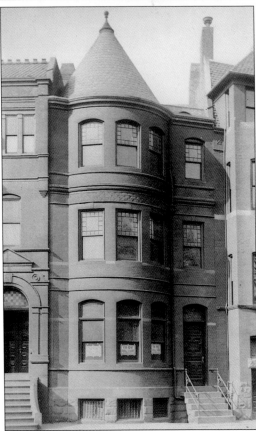

The house that once stood at 5 Dupont Circle was home to William Howard Taft. (Courtesy of the Library of Congress.)

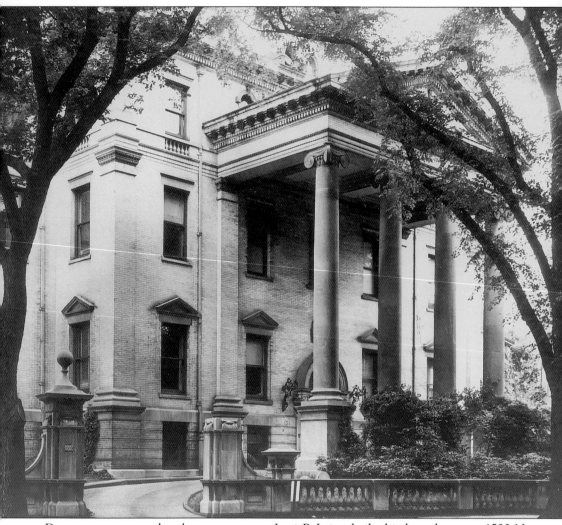

Department store and real estate magnate Levi P. Leiter built this large house at 1500 New Hampshire Avenue on the Circle in 1891. It was designed by architect Theophilus P. Chandler and was torn down in 1947 to make way for the Washington Plaza Hotel. (Courtesy of the Library of Congress.)

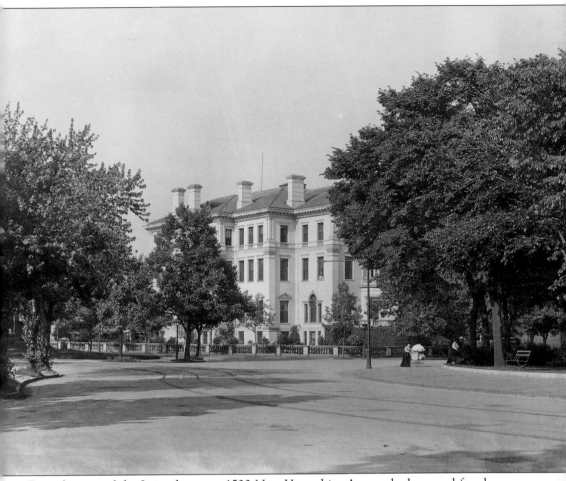

Even the rear of the Leiter house at 1500 New Hampshire Avenue had a grand façade, seen here from the Circle around 1900. Anticipating Prohibition, the Leiter family stocked the cellar of the house with $300,000 worth of the finest wines and liquors. (Courtesy of the Library of Congress.)

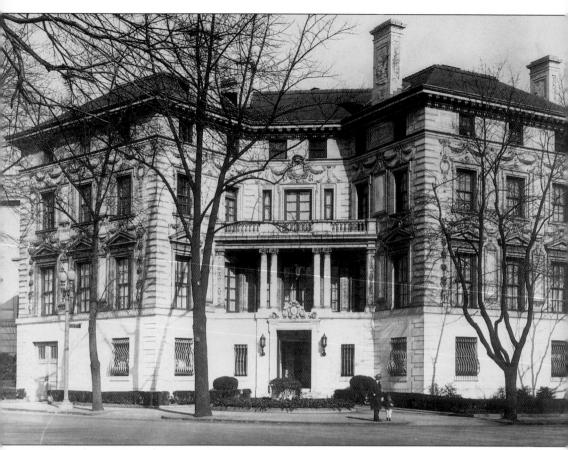

One of two private homes in Washington designed by famous architect Stanford White, the white marble Patterson House at 15 Dupont Circle was constructed in 1903 for Mrs. Robert Wilson Patterson. Her renegade daughter Cissy often fought publicly with social rival Alice Roosevelt Longworth. Today the house hosts the Washington Club, an elite social club for women. (Courtesy of the Library of Congress.)

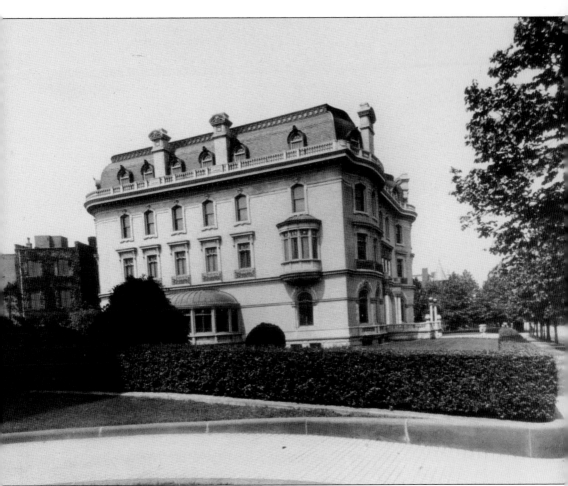

Perhaps the most lavish home built around Dupont Circle was that of Irish-born Thomas F. Walsh, who in 1903 built a 60-room mansion at 2020 Massachusetts Avenue for his daughter Evalyn. Walsh had made a fortune with a Colorado gold mine when he had the house built at a cost of $800,000, complete with a large piece of gold ore buried above the main entrance. Evalyn went on to marry Edward Mc Clean, whose family owned the *Washington Post* and who negotiated in a dressing room of the house to buy the her the infamous Hope Diamond. The house now serves as the Indonesian Embassy. (Courtesy of the Library of Congress.)

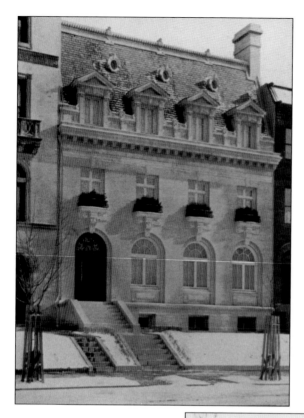

This house at 1609 Connecticut Avenue was designed by the architectural firm of Wyeth & Cresson (Courtesy of the Washingtoniana Division, MLK Library.)

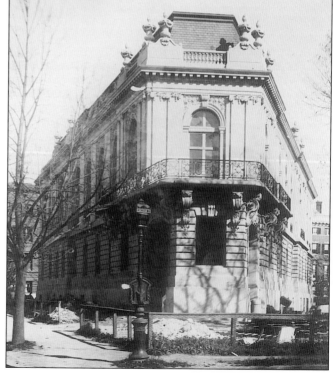

This large and impressive mansion was built in 1909 for Perry Belmont, the grandson of Commodore Matthew Perry, at 1618 New Hampshire Avenue at a cost of $1.5 million. It was designed by architects Etienne Sansom and Horace Trumbauer. (Courtesy of the Library of Congress.)

Architect Jules Henri de Sibour's drawings for the lavish home at 1746 Massachusetts Avenue include fine detailings that owner Clarence Moore would enjoy upon the structure's completion in 1909. (Historic American Building Survey; courtesy of the Library of Congress.)

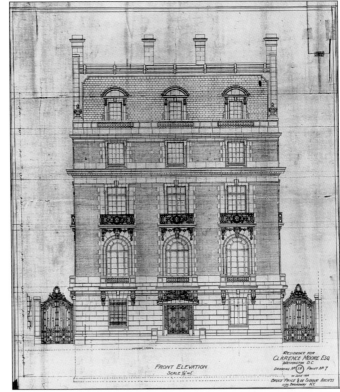

The interior library at 1746 Massachusetts Avenue featured intricate wood carvings. The building later served as the Canadian Embassy when photographed in 1945. (Courtesy of the Washingtoniana Division, MLK Library.)

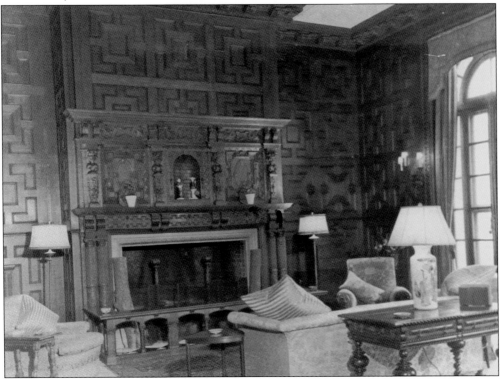

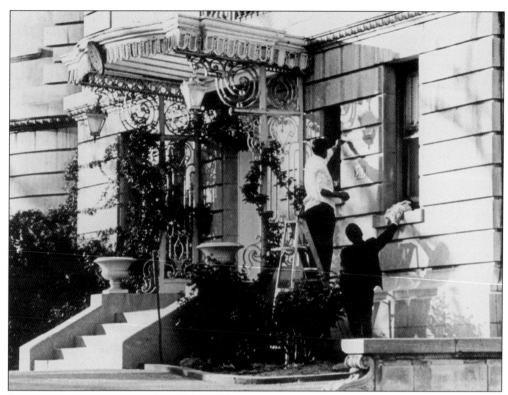

Exterior maintenance is performed by workmen on the former mansion that was serving as the Pakistan Embassy at 2133 Massachusetts Avenue when this photograph was taken in the 1950s. (Courtesy of the Washingtoniana Division, MLK Library.)

When this photograph ran in a 1945 edition of the *Washington Star*, the house was serving as the Guatemalan Embassy. (Courtesy of the Washingtoniana Division, MLK Library.)

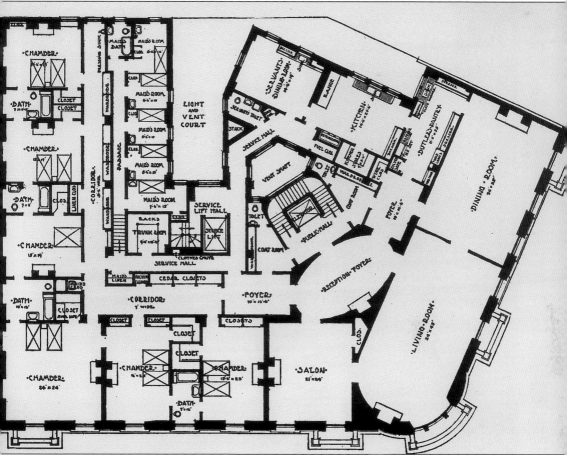

Owner Stanley McCormick hired architect Jules Henri de Sibour to design the luxurious apartment house at 1785 New Hampshire Avenue in 1915. Each of the five floors held only one apartment, had features such as a trunk room and five maid's quarters, and were rented to such notables as Andrew Mellon. (Historic American Building Survey; courtesy of the Library of Congress.)

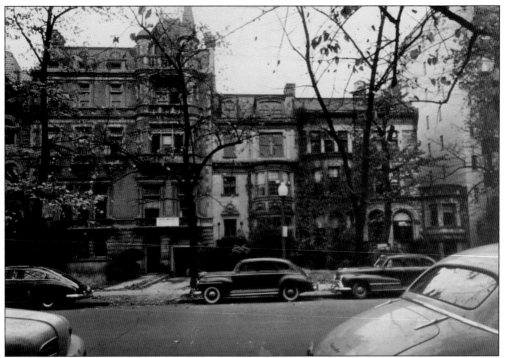

These houses at 1707 to 1711 Massachusetts Avenue were demolished after this photograph was taken in 1949 for the construction of the Boston House Apartment building. (Courtesy of the Washingtoniana Division, MLK Library.)

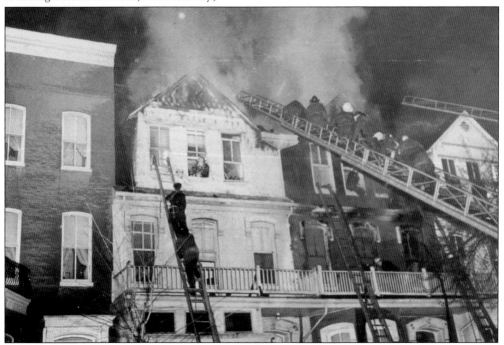

The *Washington Daily News* captured a fire in progress in these townhouses located at 2024 to 2026 P Street. (Courtesy of the Washingtoniana Division, MLK Library.)

Four

COMMERCIAL BUILDINGS

Dupont Circle's development began with residential architecture and few commercial buildings other than small shops and street vendors to supply the community's needs. Large markets and department stores downtown supplied food, clothing, and furnishings during the early development of the Circle. However, as land prices rose and the area's population increased, the neighborhood's main corridors and the Circle itself began to evolve into commercial uses.

Many of the townhomes still seen along Connecticut Avenue were converted into stores and restaurants, with offices above, shortly after the turn of the twentieth century. Others dating from the 1870s were razed and replaced with elegant storefronts that have hosted decades of premier shopping venues. Exclusive, world-class designers and apparel stores made the avenue the shopping district in the city in the 1960s before suburban malls were introduced.

The fate of many of the lavish mansions on the Circle itself, however, was more devastating, Many were torn down from the 1950s to the 1970s and replaced with tall office buildings of no particular architectural merit. The Leiter House was replaced by the Washington Plaza Hotel by 1950, the large Hilton Hotel replaced a country estate and the Treaty Oak in the 1960s, and the Hitt House was razed and replaced by a mundane office building in the 1970s.

The Cairo Apartment building at 1615 Q Street was under construction in 1894 and cost $450,000. Designed by local architect Franklin T. Schneider, it set off a flurry of protests among residents concerned over its height, leading to the passing of Washington's height restriction legislation. (Courtesy of the Historical Society of Washington.)

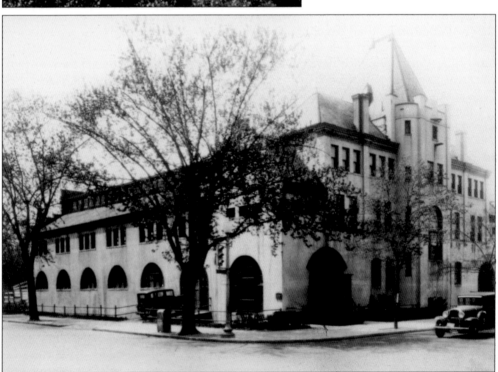

Now the site of a new gas station, the intersection at Twenty-second and P Streets was once the home of the Washington Riding Club. It still held stables and horses at the time this image was taken, about 1929. Courtesy of the Historical Society of Washington.)

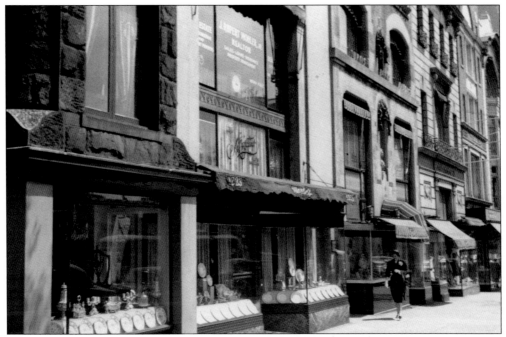

Local prolific photographer John Wymer captured this commercial scene at N and Connecticut Avenue on April 20, 1952, during the time the area was the unsurpassed and exclusive shopping street of Washington. (Courtesy of the Historical Society of Washington.)

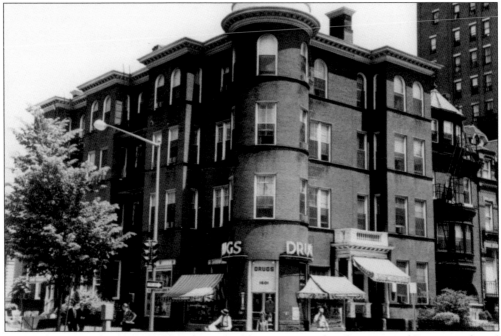

Pictured in 1963, this large and handsome building once stood at the corner of Seventeenth and Q Street, housing apartments and a drugstore, until it was replaced by the current commercial building that houses a nightclub and retail stores. (Courtesy of the Historical Society aThe elegant Chasteleton Apartment building at 1701 Sixteenth Street was designed by Philip M.

Jullien in 1920 in an unusual Neo-Gothic style. Immediately after finishing the southern half, the architect was commissioned to duplicate the structure, and double its size to the north, making it the largest apartment building in Washington at the time. (Courtesy of the Library of Congress.)

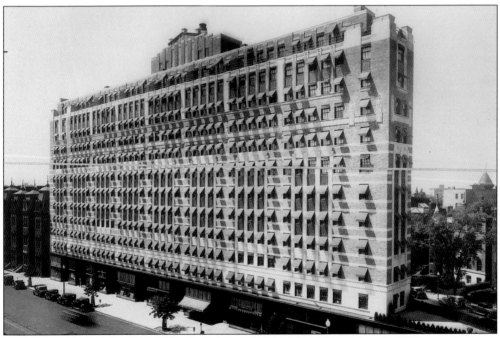

Architect Mihran Mesrobian designed this triangular shaped building in 1931 as a 700-unit apartment building; the structure replaced a row of townhouses along Connecticut Avenue and the southern edge of the Circle. (Courtesy of the Library of Congress.)

The Mayflower Hotel at 1127 Connecticut Avenue was completed in 1924, shortly before this photograph was taken, and almost instantly became one of the most fashionable places to stay for visiting dignitaries and part-time Washington residents of prominence. (Courtesy of the Washingtoniana Division, MLK Library.)

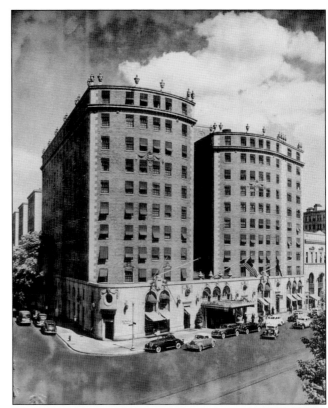

The lobby of the Mayflower Hotel was furnished with enormous oriental rugs and exotic furnishings of the day. Notable guests included Mr. and Mrs. William K. Vanderbilt, who visited in May 1932. (Courtesy of the Washingtoniana Division, MLK Library.)

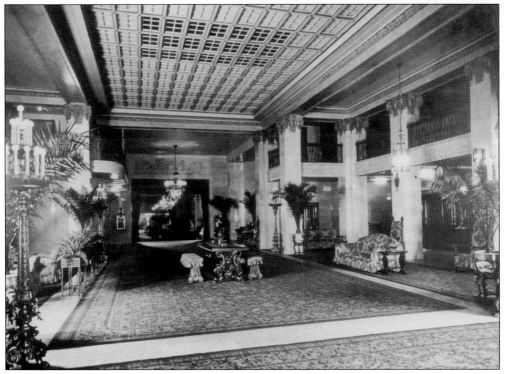

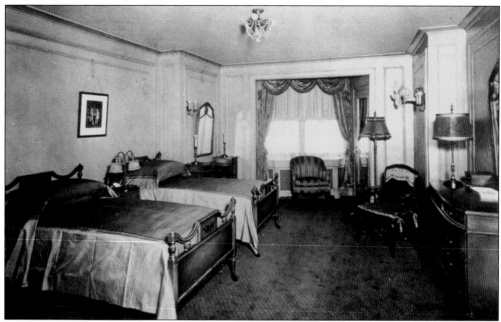

A typical room at the Mayflower Hotel was decorated with furnishings of the day, including a wall-mounted fan. The hotel also offered apartment suites and hosted such notables as Huey Long, Franklin D Roosevelt, Alice Roosevelt Longsworth, Harry Truman, and several family parties for John F. Kennedy. (Courtesy of the Washingtoniana Division, MLK Library.)

The Mayflower's ballroom, pictured during its 25th anniversary, has hosted an inaugural ball for every president since Calvin Coolidge and was once witness to the scene of Gene Autry riding his horse Champion through the lobby. It also was the daily lunch spot for FBI director J. Edgar Hoover from 1952 to 1972. (Courtesy of the Washingtoniana Division, MLK Library.)

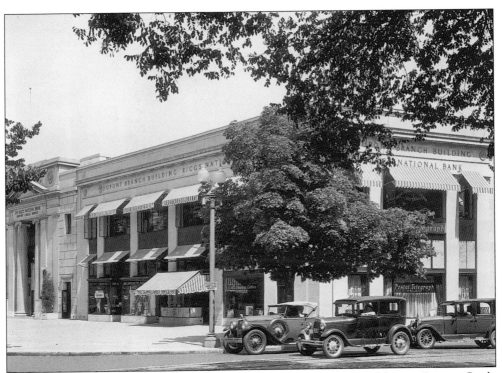

Photographer Theodor Horydczak took this image of the Riggs Bank Building on Dupont Circle in the 1930s. The structure replaced Stewart's Castle, signaling the commercial introduction to the area surrounding the Circle. (Courtesy of the Library of Congress.)

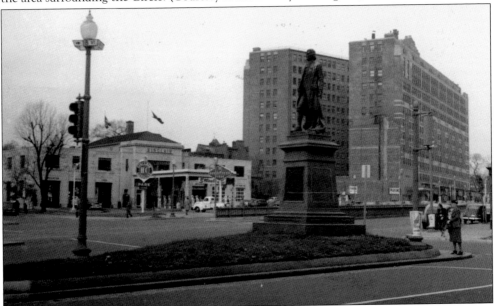

Behind the Dupont Circle Building in the intersection of Connecticut and Eighteenth Street stands a statue of John Witherspoon of New Jersey. It was sculpted by William Couper. This scene was photographed in 1950 when an elaborate gas station was located on the opposite corner. (Courtesy of the Historical Society of Washington.)

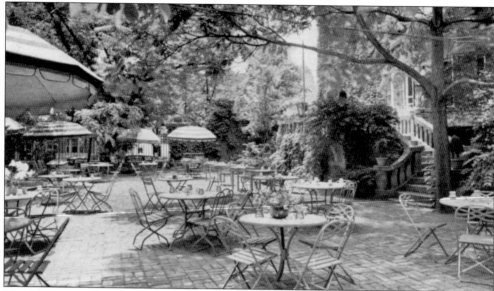

The large Fraser mansion at the corner of R and Connecticut Avenue was converted into the Parrot Restaurant, a favorite outdoor destination for many Washingtonians until it closed in the 1950s, later serving as the Four Seasons Restaurant. (Courtesy of the Historical Society of Washington.)

Photographed in 1963, this section of Seventeenth Street between Q and Corcoran Streets is the site of Annie's Steak House, a popular restaurant and destination of gay residents that still exists to this day. (Courtesy of the Historical Society of Washington.)

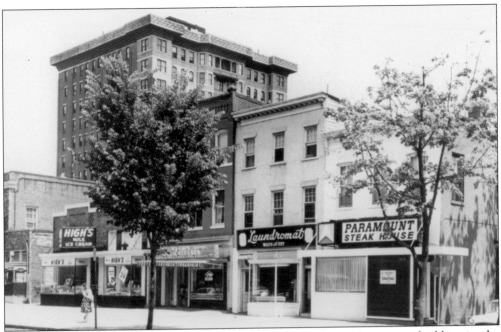

The corner of Seventeenth Street and Church, with the Cairo Apartment building in the background, was captured by photographer John Wyman in 1963. The corner store then housed the Paramount Steak House, which later became Annie's Steak House further up the street. It is now occupied by the tremendously popular gay establishment known as JRs Bar & Grill. (Courtesy of the Historical Society of Washington.)

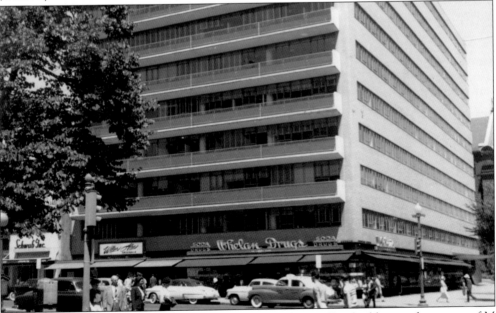

Photographed shortly after its completion in 1951, the large office building at the corner of M Street and Connecticut Avenue was designed with rows of ribbon windows by famous architect William Lescaze. Although still standing, the structure has been significantly modified since. (Courtesy of the Historical Society of Washington.)

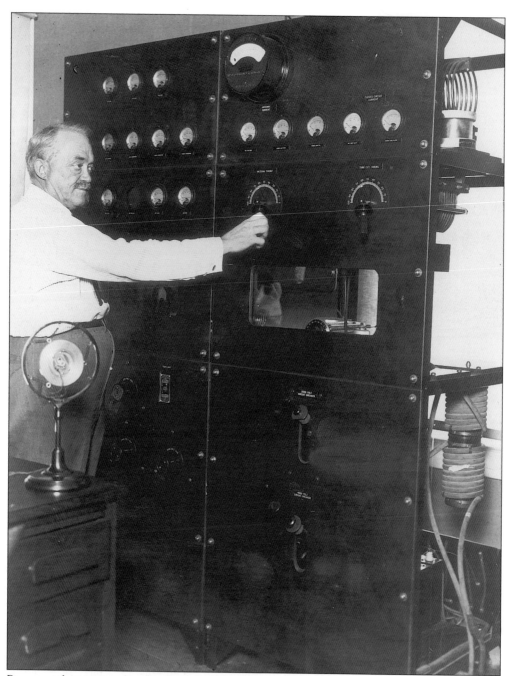

Pioneer television and radio inventor Dr. Charles Francis Jenkins demonstrates the main transmitting panel of the radio movie broadcasting station at 1519 Connecticut Avenue. It was established in 1928 as the first licensed television station in America with the call letters W3XK. (Courtesy of the Library of Congress.)

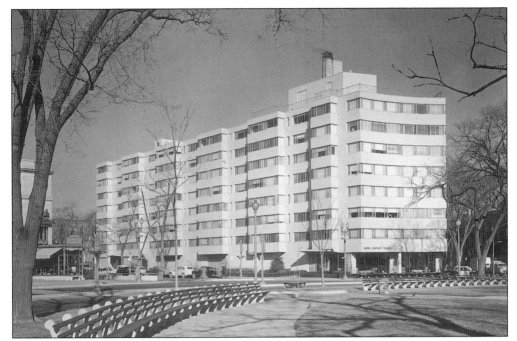

The Hotel Dupont Plaza replaced the lavish Leiter mansion and several other townhouses when it was built beginning in 1950. In the foreground are the new benches installed in the Circle and a much less dense vegetative landscape than existed prior. (Courtesy of the Library of Congress.)

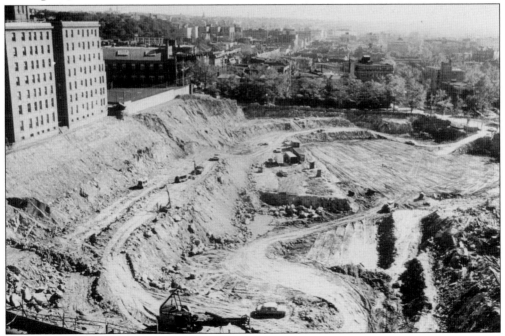

This image of the large hole created to accommodate the Hilton Hotel construction appeared in the October 16, 1962 edition of the *Washington Post*. (Courtesy of the Washingtoniana Division, MLK Library.)

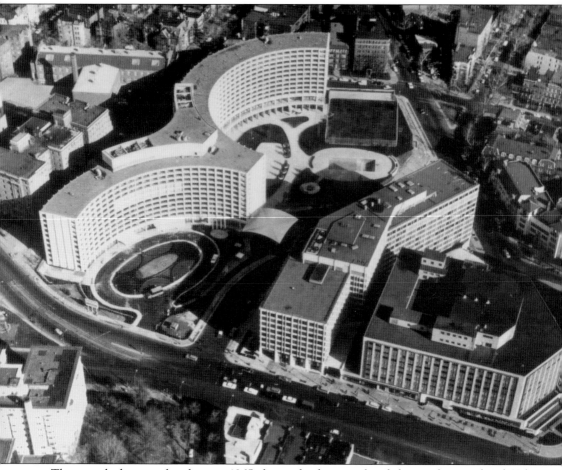

This aerial photograph taken in 1965 shows the large scale of the newly completed Hilton Hotel, which has hosted a variety of political parties and events since its opening. It was also the location at which John Hinkley shot President Ronald Reagan in 1981. (Courtesy of the Washingtoniana Division, MLK Library.)

Five

INSTITUTIONS

Sprinkled among its numerous residential structures, Dupont Circle has also held a variety of churches, schools, and institutional buildings since the neighborhood's beginning. Early wood frame chapels that once existed in the rural setting were replaced with more significant, architect-designed churches as the population and congregation sizes grew rapidly in the 1880s and 1890s.

Many of the former mansions were converted over the years into private boarding and finishing schools for boys and girls, or were acquired for ambassador and embassy uses after the turn of the twentieth century. In the 1910s and 1920s, local institutions such as the Scottish Rite Masons and the Carnegie Institute decided to invest in and build large administration buildings throughout the neighborhood.

Dupont Circle residents have, to this day, continued to reside among a host of buildings serving a variety of purposes; the neighborhood is one where it is not unusual to own a house that adjoins a sorority headquarters or a foreign country's embassy.

The Fairmount School, a private school for girls was located for many years at this grand former mansion at 1711 Massachusetts Avenue. It is an example of the institutional use of former homes in the Dupont Circle area in the 1930s. (Courtesy of the Washingtoniana Division, MLK Library.)

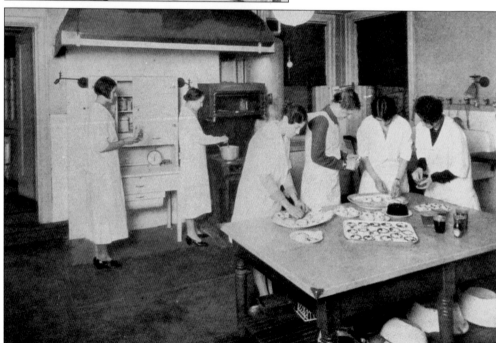

Students in the "Domestic Science" department of the Fairmount School practice their craft in the school's kitchen. (Courtesy of the Washingtoniana Division, MLK Library.)

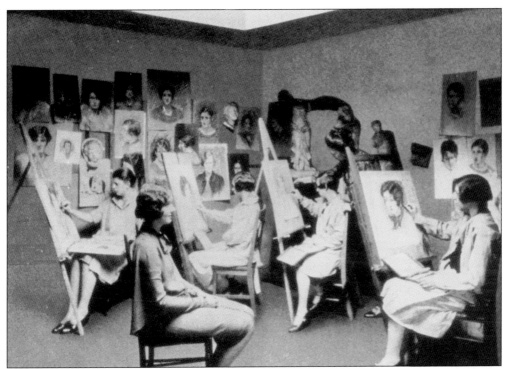

Female students of the Fairmount School studied instructional portrait painting. The institution was one of many finishing schools for young women in the Dupont Circle area. (Courtesy of the Washingtoniana Division, MLK Library.)

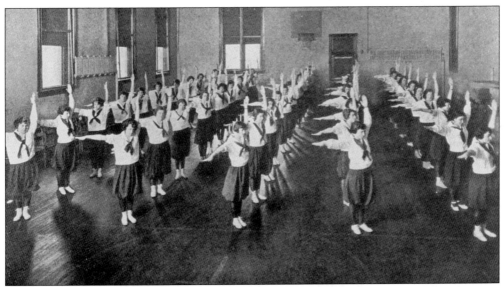

Girls in the Fairmount School were also subjected to physical fitness. In the 1930 school brochure, it was noted that a "sound body is necessary for happy living." (Courtesy of the Washingtoniana Division, MLK Library.)

The University School was one of several boys' schools located in the Dupont Circle neighborhood in a former mansion during the 1930s. Its building once stood at 1310 Eighteenth Street, NW. (Courtesy of the Washingtoniana Division, MLK Library.)

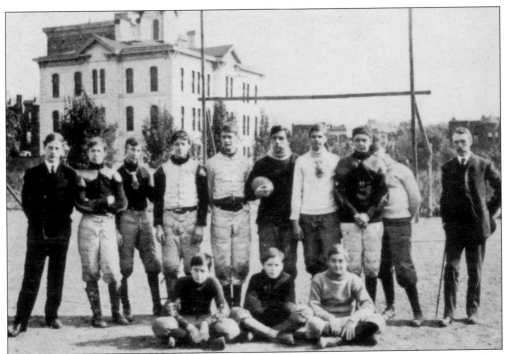

The football team of the University School is pictured here wearing little protection other than padded pants. (Courtesy of the Washingtoniana Division, MLK Library.)

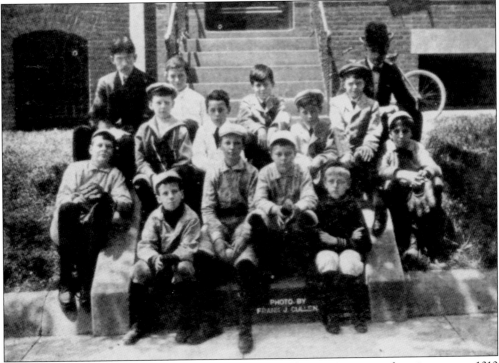

The young members of the University School's baseball team are pictured on its steps at 1310 Eighteenth Street in the 1930s. (Courtesy of the Washingtoniana Division, MLK Library.)

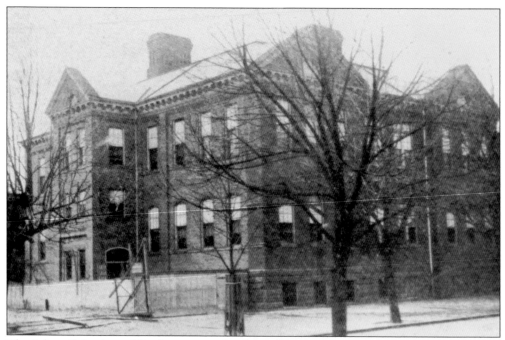

The Adams School, a public elementary school, is still located on R Street between Seventeenth and Eighteenth Street, NW. It was one of several schools that served the early residents of the emerging Dupont Circle neighborhood at the turn of the twentieth century. (Courtesy of the Washingtoniana Division, MLK Library.)

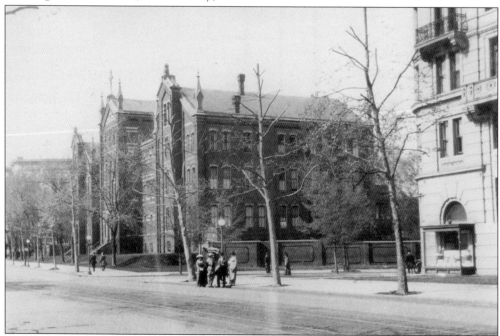

This 1910 view of the Visitation School was taken just before the structure was torn down. It was located on Connecticut Avenue between L and DeSales Street, the current site of the Mayflower Hotel. (Courtesy of the Washingtoniana Division, MLK Library.)

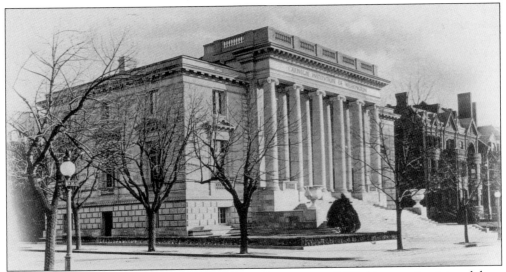

The administration building of the Carnegie Institution of Washington is pictured here immediately following its completion in 1911. It was designed by the New York architectural firm of Carrere and Hastings and was set among residential buildings, including the home of *Titanic* disaster survivor Colonel Archibald Gracie (situated to its right at 1527 Sixteenth Street). (Courtesy of the Washingtoniana Division, MLK Library.)

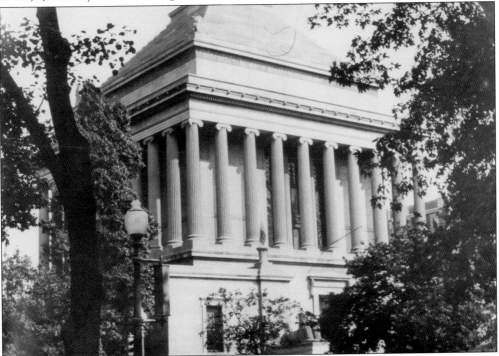

Located at 1733 Sixteenth Street, the imposing Scottish Rite Temple was designed by architect John Russell Pope in 1910 and was constructed between 1911 and 1915. Its estimated cost was also monumental at $1.1 million. The large sphinxes flanking the building's front entrance were sculpted by artist A.A. Weinman. (Courtesy of the Washingtoniana Division, MLK Library.)

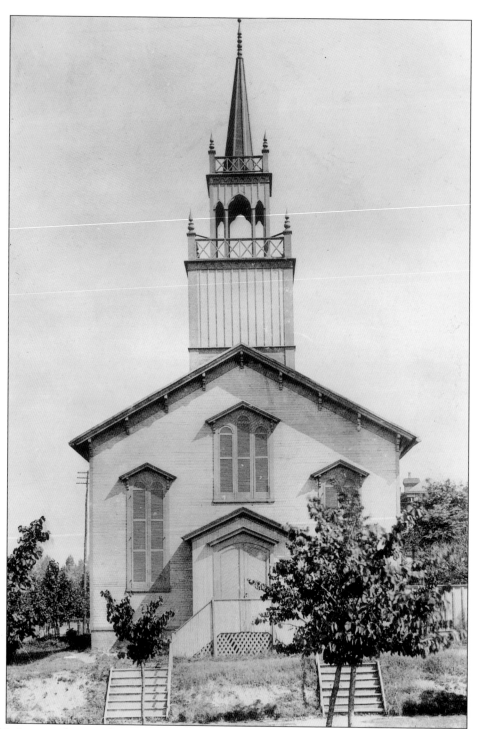

This image, taken on August 28, 1895, shows the wood frame Methodist Church in its rural setting at Fifteenth and R Streets before many townhomes were erected in the vicinity. The church was later replaced by St. Paul's Methodist Church. (Courtesy of the Library of Congress.)

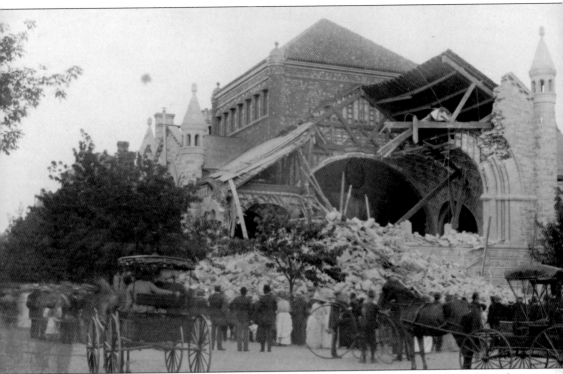

Spectators gather at Eighteenth and N Streets to witness the devastation resulting from the collapse of the Church of the Covenant's tower on August 22, 1888. (Courtesy of the Historical Society of Washington.)

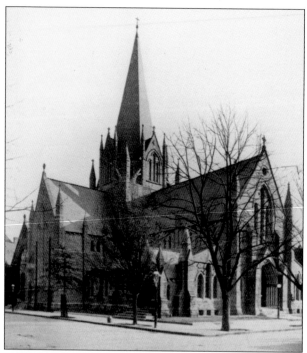

A 1912 view of St. Thomas Episcopal Church at the corner of Eighteenth and Church Streets captured architect Theophilus P. Chandler's design for the building, erected between 1894 and 1899. Parishioners decided to create an open urban park with the remains of the sanctuary, which was burned by arsonists in 1970. (Courtesy of the Historical Society of Washington.)

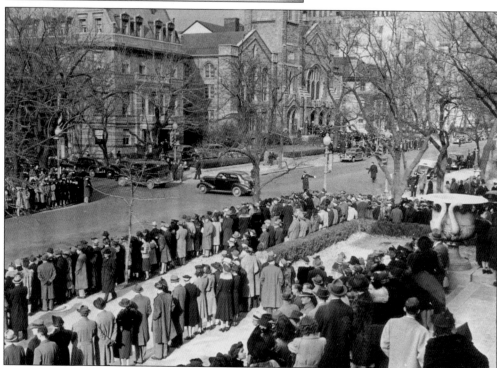

Crowds gather to watch Franklin D. Roosevelt and Winston Churchill leave the Foundry Methodist Episcopal Church on December 26, 1941. Located between P and Q Streets on Sixteenth Street, it has been the church of choice for several presidents since, including weekly visits by President Bill Clinton. (Courtesy of the Washingtoniana Division, MLK Library.)

Six

WORLD WAR II TO HISTORIC DISTRICT STATUS

As its buildings aged and the city of Washington began to focus its efforts on supporting the country during World War II, Dupont Circle began to change from a wealthy residential enclave to a gathering place for national and local protests. Thousands of female government workers flooded into the area to search for shared rooms during the war years. Like many urban parks of the era, Dupont Circle also became home to hundreds of homeless people, hippies, and low-income renters who took advantage of the cheap stays that could be had at rooming houses and places of ill repute.

Former mansions were converted or outright demolished for office buildings or other commercial entities. The Circle itself became a central location for early gay rights protests in Washington, attracting homosexuals from other parts of the country to participate under the leadership of Frank Kameny and local business owner Deacon Maccubbin. It was also the gathering point for years of anti–Vietnam War protests, culminating in May 1971. Local outrage at the failure of several prominent historic preservation projects resulted in the area's designation as a historic district in 1977, paving the way for the renovated and desirable neighborhood that exists around the Circle today.

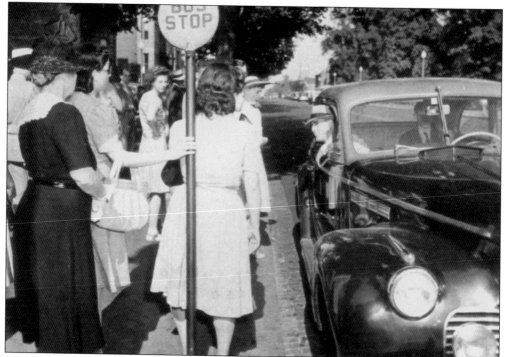

The April 21, 1942 issue of the *Washington Star* showed these government workers and members of the "Share-A-Ride Club" conserving gasoline during the beginning of World War II. (Courtesy of the Washingtoniana Division, MLK Library.)

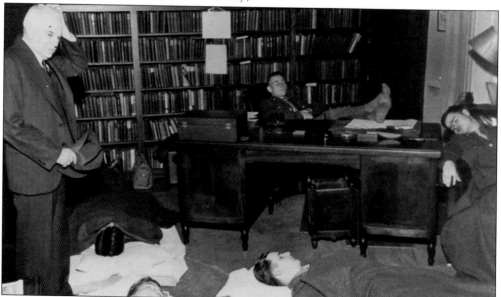

As was somewhat typical during the World War II era in cramped Washington, Reverend Dr. Albert J. McCartney, pastor of the Covenant First Presbyterian Church, finds servicemen sleeping in the study of the church's "Friendship House" at 1229 Connecticut Avenue in January 1945. (*Washington Star* photograph; courtesy of the Washingtoniana Division, MLK Library.)

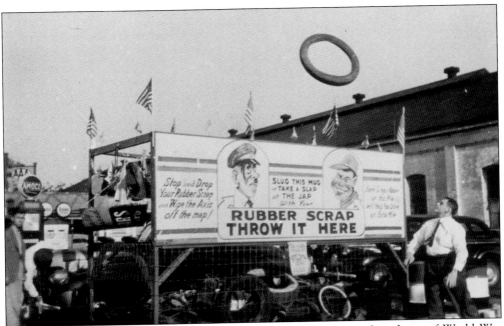

Dupont Circle citizens did their part to conserve materials during the advent of World War II, as did the rest of America. This rubber scrap heap was set up in 1942 to assist in reminding residents of Washington to conserve and recycle for the war effort. (*Washington Star* photograph; courtesy of the Washingtoniana Division, MLK Library.)

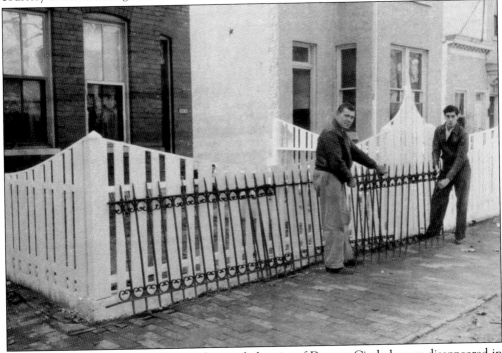

Many of the ornate fences and wrought-iron balconies of Dupont Circle houses disappeared in the 1940s, put to patriotic use for the war effort. These unidentified gentlemen replace their gate with a wooden picket fence. (Courtesy of the Washingtoniana Division, MLK Library.)

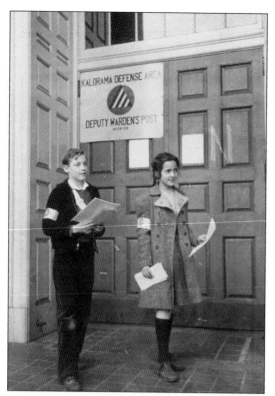

Youngsters assist in the "Kalorama Defense Area" as civilian defense volunteers, offering Dupont Circle citizens information and advice in the event of a nuclear attack on the city following World War II. (Courtesy of the Washingtoniana Division, MLK Library.)

The World War II effort brought thousands upon thousands of temporary employees to Washington, and many of the Dupont Circle mansions became rooming houses to assist in the war effort. "Working girls" often shared rooms in shifts as temporary government buildings were erected on the Mall and operated 24 hours a day. (Courtesy of the Washingtoniana Division, MLK Library.)

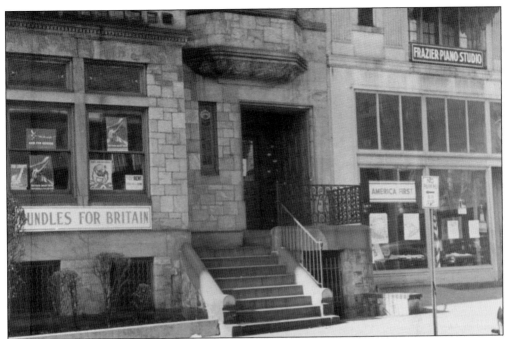

The *Washington Star* newspaper recorded this dichotomy of offices in the winter of 1941 at 1710 and 1712 Connecticut Avenue—one advertises "Bundles for Britain" and the adjoining office proclaims "America First." (*Washington Star* photograph; courtesy of the Washingtoniana Division, MLK Library.)

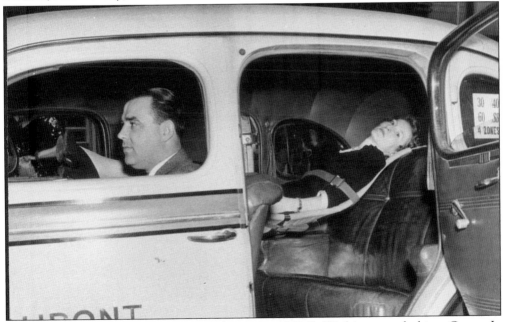

Continuing the World War II effort in the spring of 1942, Washington cab driver George L. Fentress Jr. demonstrates how to provide portable aid for the injured to "victim" Alice Nelson by utilizing a portable stretcher. (*Washington Star* photograph; courtesy of the Washingtoniana Division, MLK Library.)

Local artist Lillian Spandorf was captured in a *Washington Star* photograph by Gene Abbott in 1966. She made her home in Dupont Circle and eventually became a staff artist for the *Star*, sketching many Dupont Circle activities throughout the next few decades. (*Washington Star* photograph; courtesy of the Washingtoniana Division, MLK Library.)

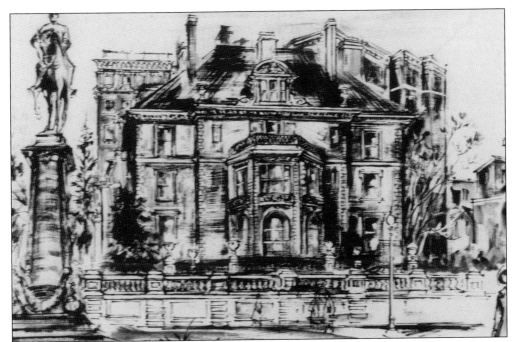

Lily Spandorf also sketched architecture around the city, including the Lothrup Mansion at the apex of Connecticut Avenue and Columbia Road, NW. The 40-room mansion was built in 1911 by Alvin Mason Lothrup, one of the founders of Woodward and Lothrup Department store. (Courtesy of the Washingtoniana Division, MLK Library.)

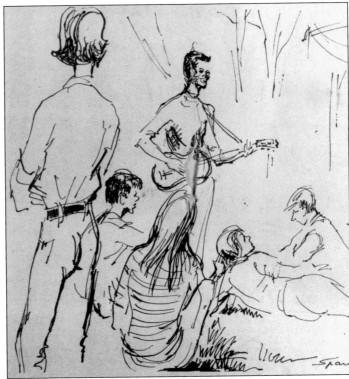

Lillian Spandorf sketched a few of the men who frequented Dupont Circle in this illustration for the *Washington Star* that ran in the May 27, 1968 issue. The Circle had become a discreet gathering place for the city's gay citizens who were organizing governmental employment for openly homosexual men. (Courtesy of the Washingtoniana Division, MLK Library.)

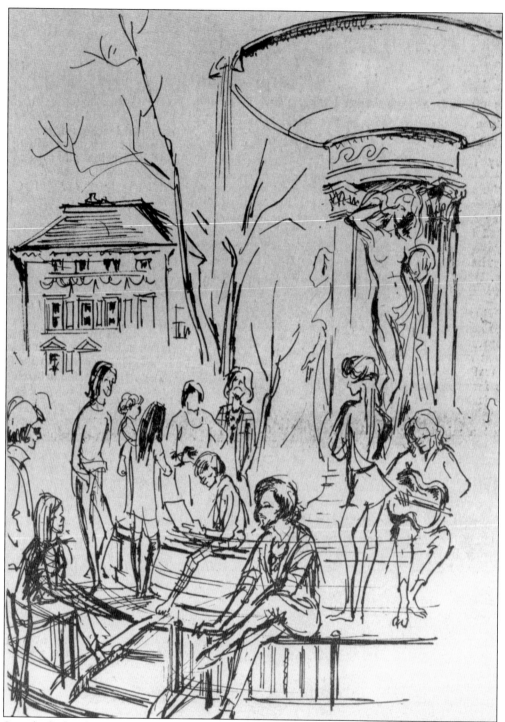

Spandorf's sketch in 1968 for the *Washington Star* newspaper shows the Circle as a gathering place for the area's young and often a "hippie" crowd. Shortly thereafter, the Circle and surrounding areas began to attract a variety of young protesters, the homeless, and indigents. (Courtesy of the Washingtoniana Division, MLK Library.)

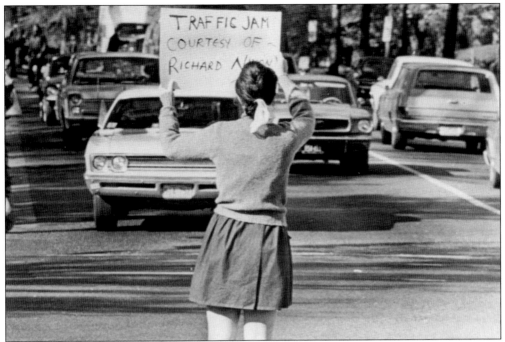

On May 6, 1971, anti-Vietnam activists orchestrated a massive shut down of traffic in and out of the nation's capitol, blocking automobile traffic throughout the city, including Dupont Circle. (*Washington Star* photograph by Bernie Boston; courtesy of the Washingtoniana Division, MLK Library.)

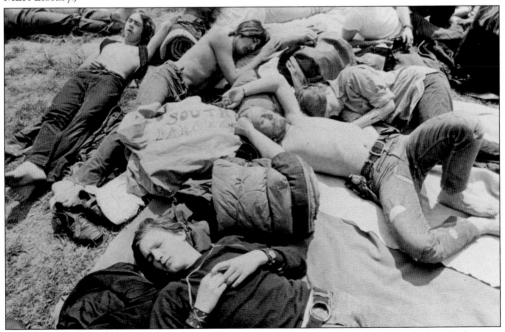

Vietnam protesters in May 1971 were photographed sleeping in Dupont Circle by *Washington Star* photographer Brig Cabe on May 1, 1971. (Courtesy of the Washingtoniana Division, MLK Library.)

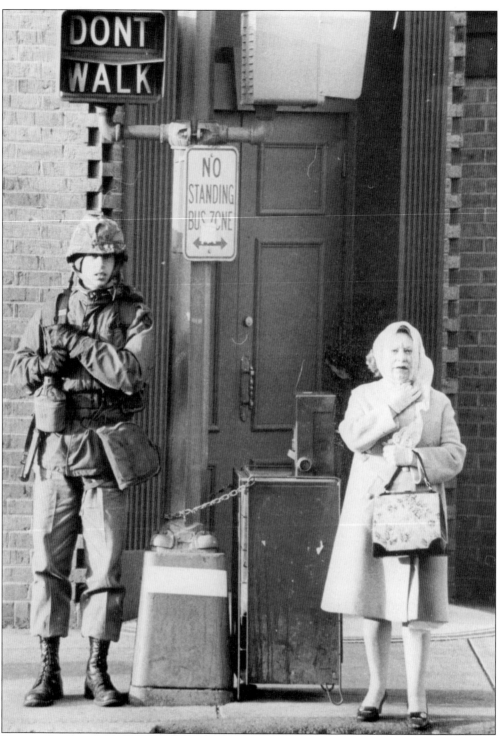

Dupont Circle and the city of Washington were under heightened alert during the protests in May 1971. This unusual paradox of a soldier and elderly resident was captured by *Washington Star* photographer Ken Heinen. (Courtesy of the Washingtoniana Division, MLK Library.)

As the police struggled to maintain control, several Dupont Circle campers and protesters, demonstrating against the government involvement in the Vietnam War, were arrested and removed from the city parks. (*Washington Star* photography by Ken Heinen; courtesy of the Washingtoniana Division, MLK Library.)

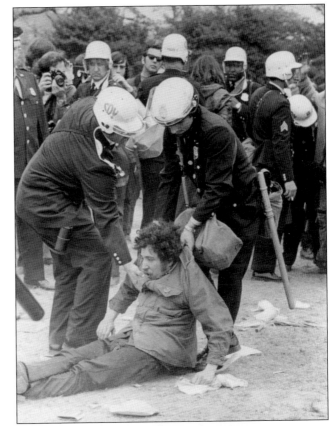

The police presence around the Circle in May 1971 was constant. These cycle officers converse with war protesters of the era. (*Washington Star* photograph, courtesy of the Washingtoniana Division, MLK Library.)

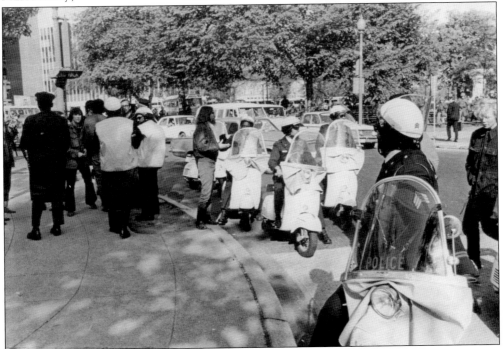

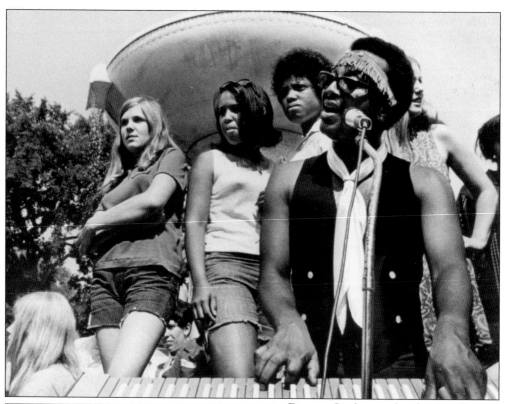

Dupont Circle was also the site of many musical performances, both formal and informal. In August 1969, members of the "Young Senators" band and four other bands played to crowds and area residents. (*Washington Star* photograph by John Bowden; courtesy of the Washingtoniana Division, MLK Library.)

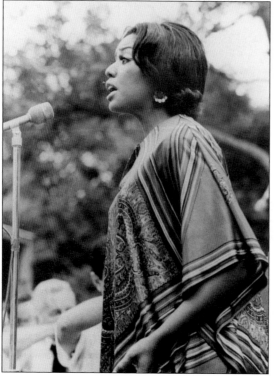

The *Washington Daily News* captured local opera singer Loretta Young singing "Depuis de Jour" from Charpentier's *Louise* and a selection from Gershwin's *Porgy and Bess* during a National Symphony concert in the Circle on August 20, 1971. (Courtesy of the Washingtoniana Division, MLK Library.)

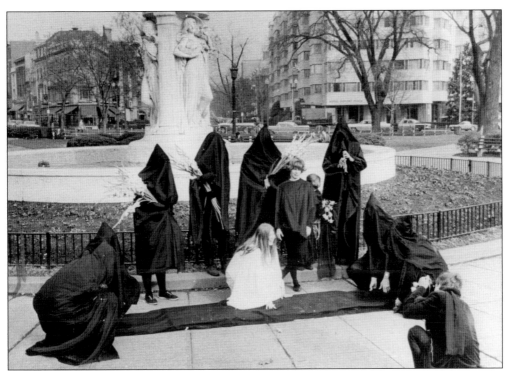

Dupont Circle has been featured in numerous motion pictures, both locally and Hollywood produced. In 1965, a few members of the cast of Roderick Bradley's movie *The Encounter* play out a scene before his camera. In white is Bradley's 18-year-old sister Sandra, playing the film's heroine. (Courtesy of the Washingtoniana Division, MLK Library.)

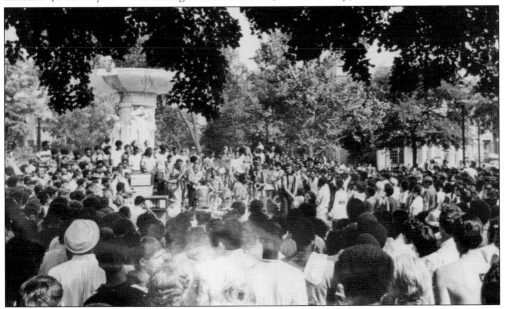

Washington Star photographer John Bowden captured a typical Dupont Circle gathering and band-playing session on September 24, 1969. (Courtesy of the Washingtoniana Division, MLK Library.)

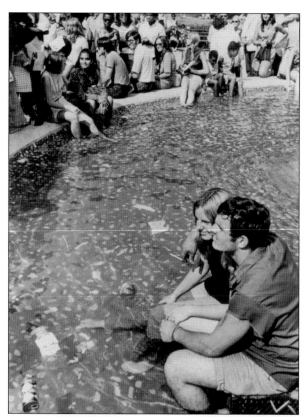

Despite floating cigarette boxes and used cola cans, area residents enjoy cooling off in the Dupont Circle fountain in the summer of 1969. (*Washington Star* photograph by John Bowden; courtesy of the Washingtoniana Division, MLK Library.)

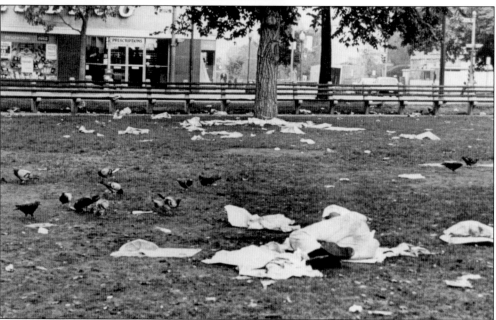

As did many urban parks during the 1960s, Dupont Circle began a slow decline during that decade, as this early morning picture from the *Washington Daily News* in 1967 clearly shows. (Courtesy of the Washingtoniana Division, MLK Library.)

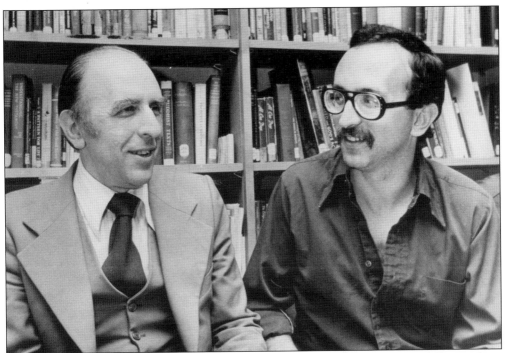

Early gay activist Frank Kameny (left) confers with Jim Zais of the Gay Activist Alliance about the treatment of homosexual citizens in the city after the 1977 fire at the Cinema Follies, a film club for gay men in Southeast Washington. Kameny would lead many protests in his Dupont Circle neighborhood against anti-gay policies. (*Washington Star* photograph by Willard Volz; courtesy of the Washingtoniana Division, MLK Library.)

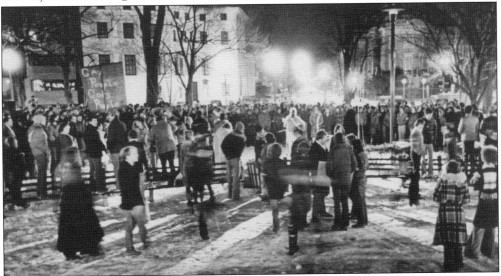

Gay citizens and supporters gathered in Dupont Circle on January 22, 1978 before a candlelight march up Connecticut Avenue to protest Florida orange spokesperson Anita Bryant's appearance before the National Religious Broadcasters Convention at the Hilton Hotel. (*Washington Star* photograph by Ray Lustig; courtesy of the Washingtoniana Division, MLK Library.)

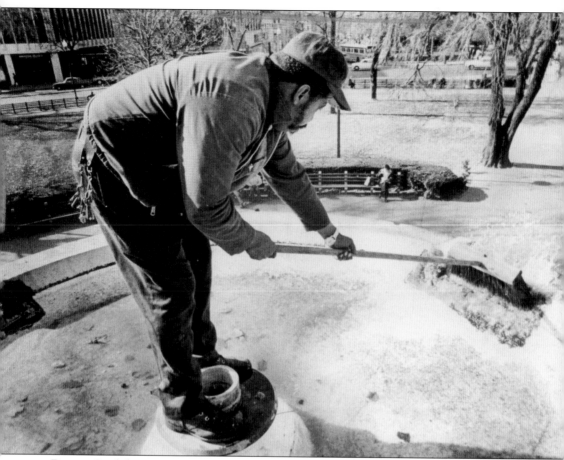

Dupont Circle began to witness a revitalization of its aging homes as a response to the demolition of several prominent mansions on the Circle and renewed interest in the park itself. Many gay urban pioneers renovated their homes. Citizens joined efforts to have the area designated a local historic district—it was on June 17, 1977 and obtained a National Register of Historic Places listing on July 21, 1978. National Park Service employee Charles Russell is pictured here cleaning the fountain bowl in November 1973. (*Washington Star* photograph; courtesy of the Washingtoniana Division, MLK Library.)